HEARTLAND

Charles Wysocki

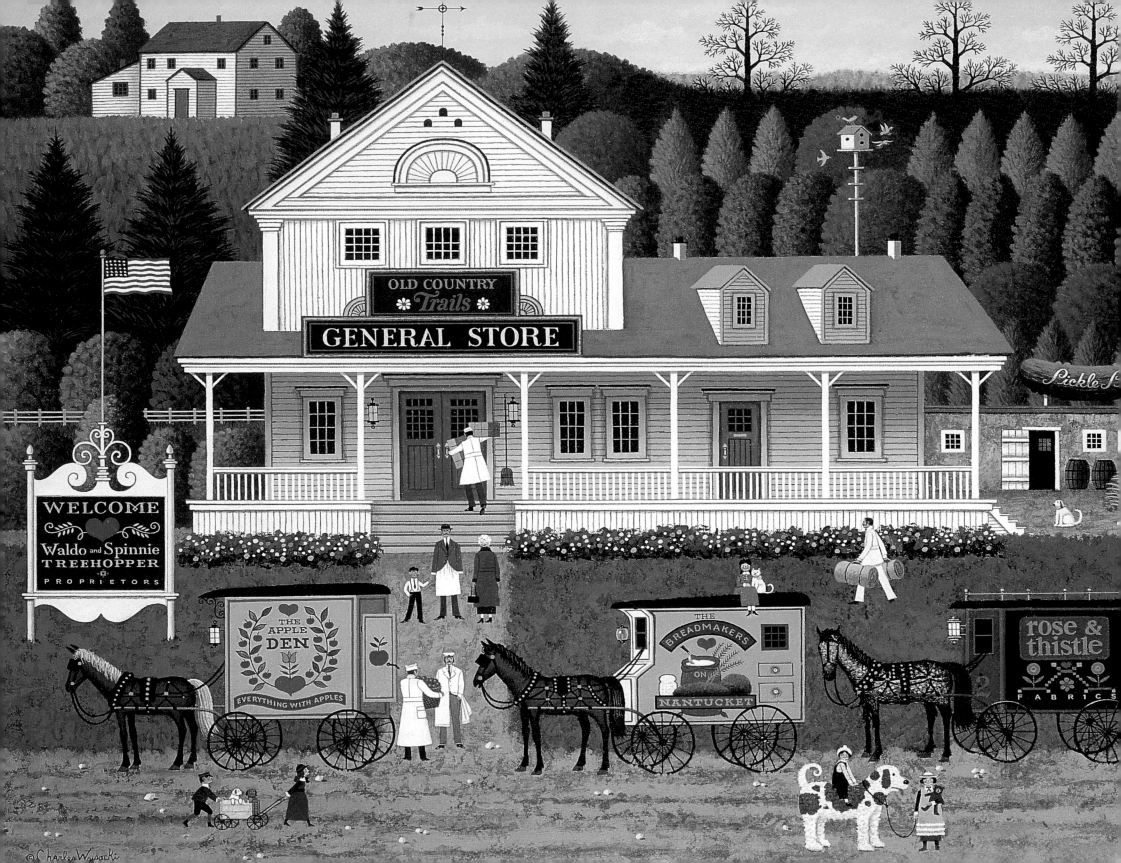

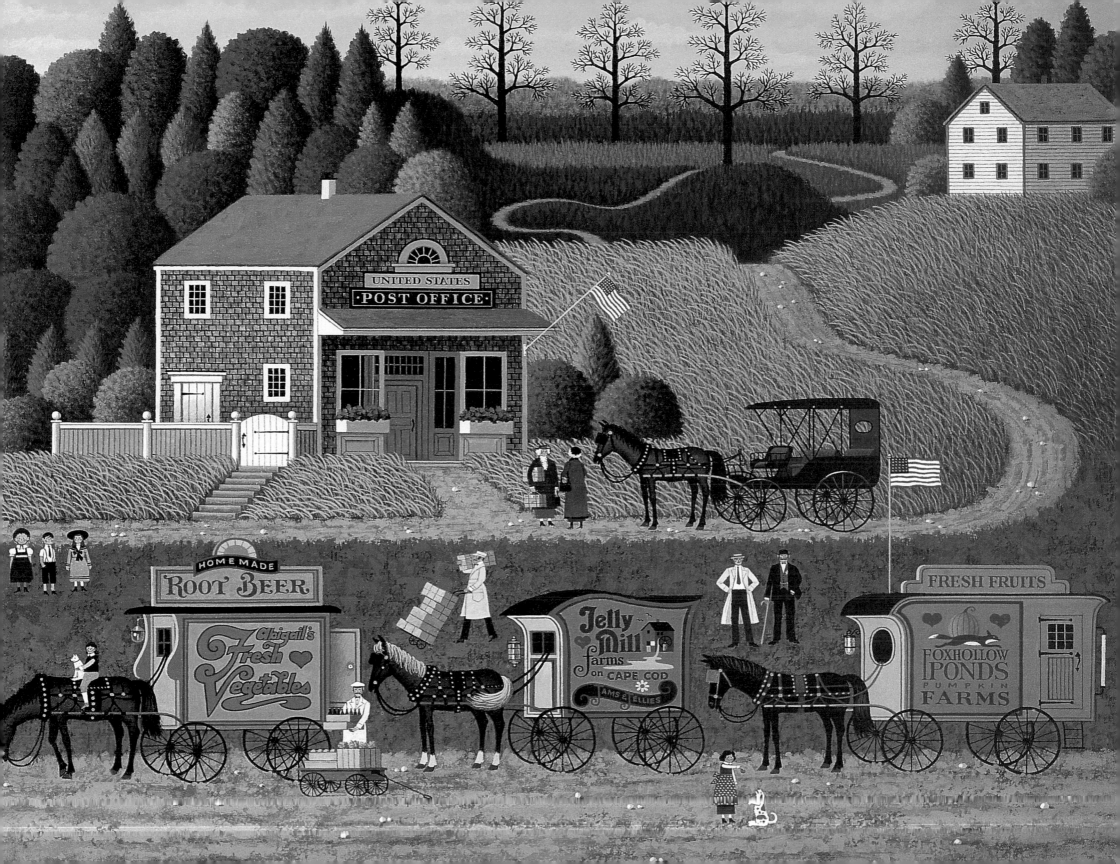

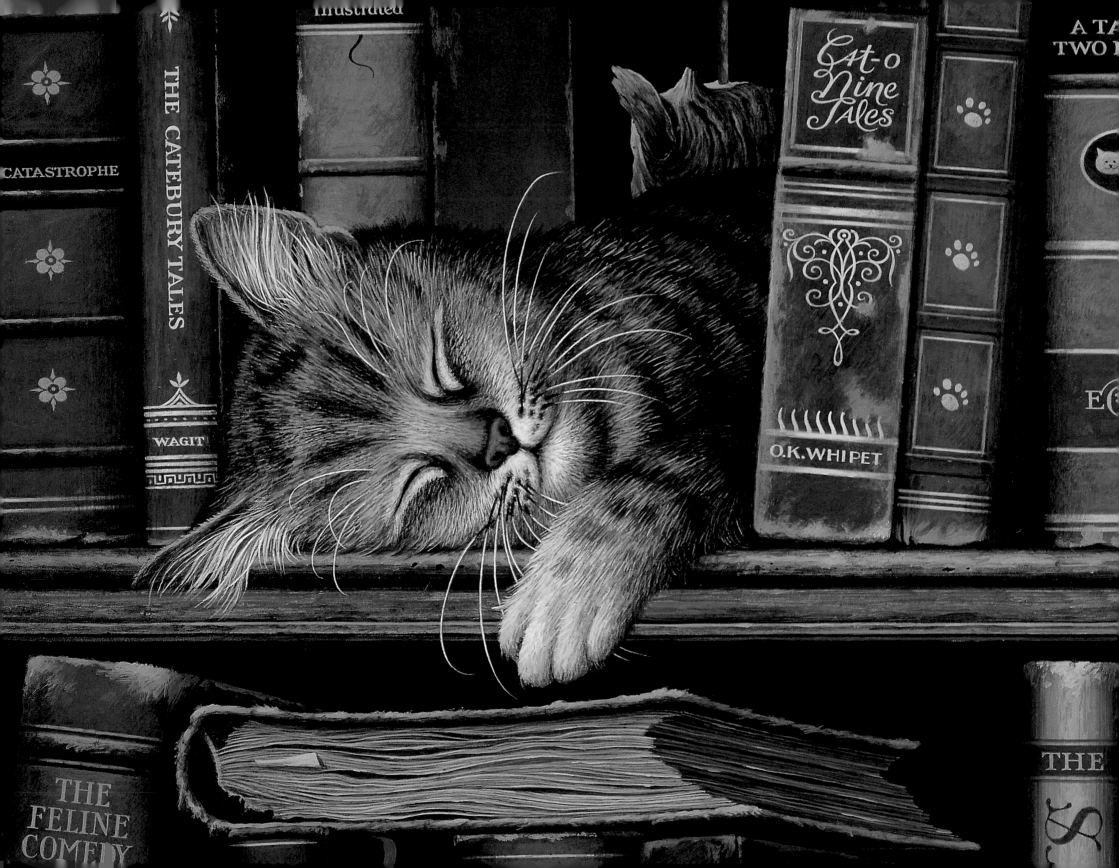

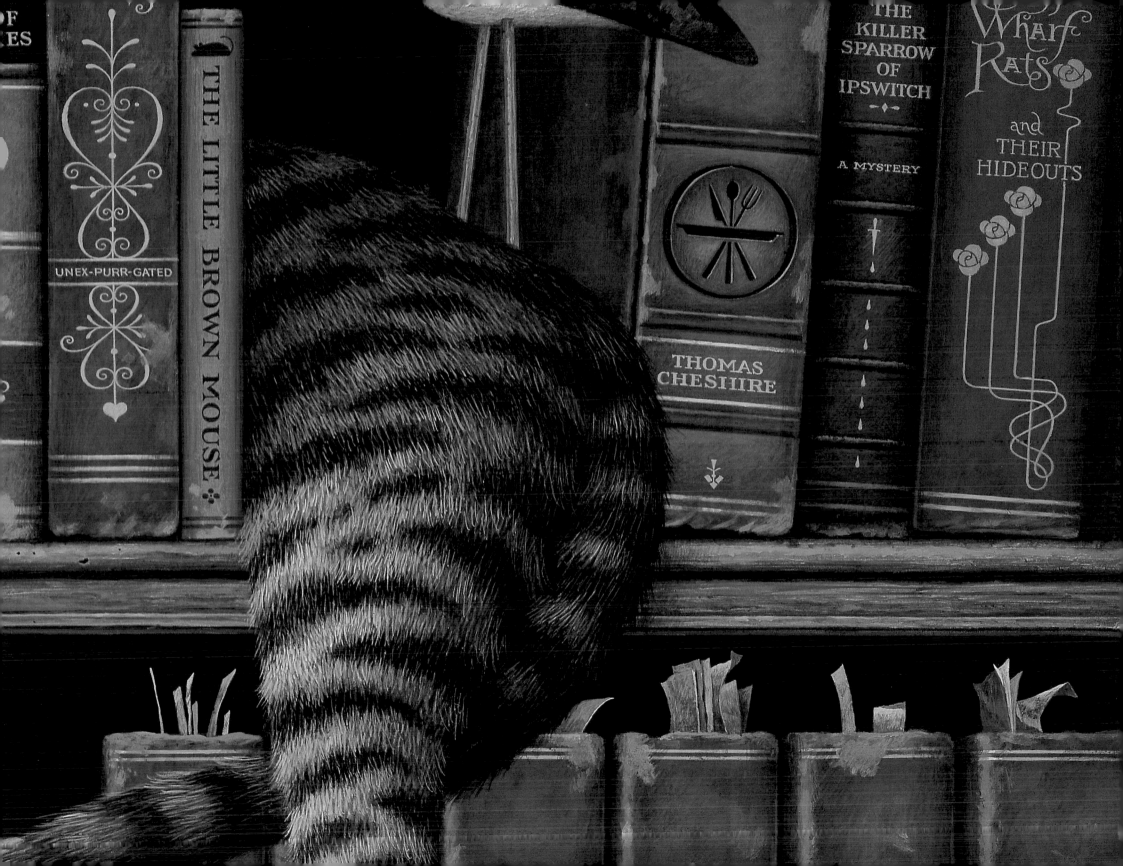

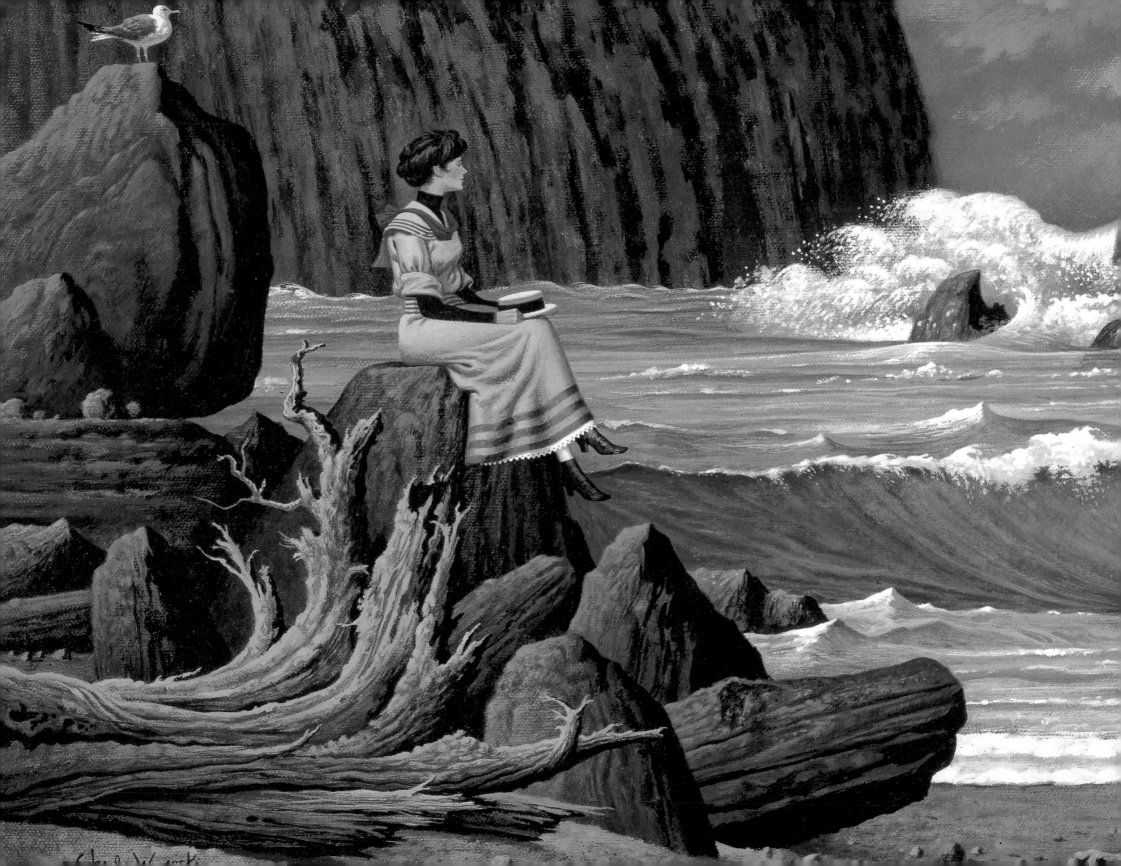

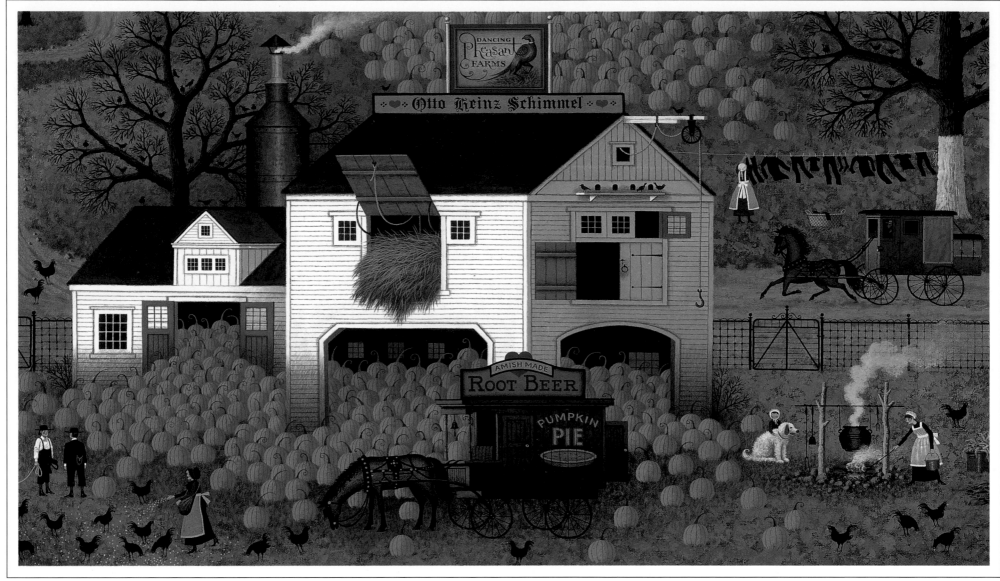

Dancing Pheasant Farms, detail

THE GREENWICH
WORKSHOP COLLECTION

HEARTLAND

Charles Wysocki

EDITED BY
ELISE MACLAY

THE GREENWICH WORKSHOP

ARTISAN · NEW YORK

This book is Dedicated to all Americans
who feel The greatness and Beauty of this Country
still Mindful Of the Simple Pleasures
in Life, Past and Present.

Published in 1994 by Artisan,
a division of Workman Publishing Company, Inc.
708 Broadway
New York, NY 10003
Library of Congress Catalogue Card Number: 93-73744
ISBN: 1-885183-05-4

Book design by Peter Landa
Printed in Hong Kong
First Printing 1994

Acknowledgments
The Greenwich Workshop expresses appreciation to the following: pp. 68–69 the White House, for use of photographs; p. 133 Time Incorporated, publishers of *People Weekly* magazine, for permission to reproduce the *People Weekly* trademark superimposed on an article about Charles Wysocki that appeared in the magazine July 7, 1986; AMCAL, for the right to reproduce the cover of the 1986 Americana Calendar, © 1985, and for the right to reproduce the painting titled *Bookstore,* © 1983, used in the ABC News advertisement on p. 133; Yankee Publishing, Inc., for the right to reproduce *Yankee* magazine covers executed by the artist. All verse by Charles Wysocki except as noted: p. 116 from *Bartlett's Familiar Quotations,* attributed to Jerome Klapka Jerome (1859–1927); p. 123 from *Bartlett's Familiar Quotations,* attributed to Beilby Porteus (1731–1808); p. 132 from *Bartlett's Familiar Quotations,* attributed to John O'Keeffe (1747–1833). In the poem on p. 17, the first and last stanzas are from the traditional *Jingle Bells* by James Pierpont. Details on pp. 2–3 from *Storin Up,* pp. 4–5 from *Frederick the Literate,* pp. 6–7 from *You've Been So Long at Sea, Horatio.*

CONTENTS

A Note From The Artist

THERE IS A COUNTRY IN MY MIND, A LANDSCAPE IN MY HEART, A PLACE THAT DOES NOT APPEAR ON ANY MAP BUT IS SO CLEAR AND SHARPLY DETAILED THAT TO PAINT IT, I HAVE ONLY TO LOOK WITHIN. IT IS A PLACE OF WONDER AND SURPRISE, INSTANTLY FAMILIAR TO ALL WHO VIEW IT WITH THE EYES OF A CURIOUS CHILD. IT IS WHERE THINGS MAKE SENSE AND LOVE HOLDS. IT IS THE PAST AS IT OUGHT TO HAVE BEEN.

AS YOU TURN THE PAGES OF THIS ALBUM, YOU WILL COME UPON A SLED, A HOUSE, A FIELD OF PUMPKINS, THE SMELL OF THE SEA— ALL THE BITS AND PIECES OF WHAT IS CALLED THE REAL WORLD—TRANSFORMED BY THE MAGIC OF IMAGINATION INTO HEARTLAND WHERE THE WELCOME IS WARM, TIME IS KIND, AND THE HEART IS FOREVER AT HOME.

Charles Wysocki

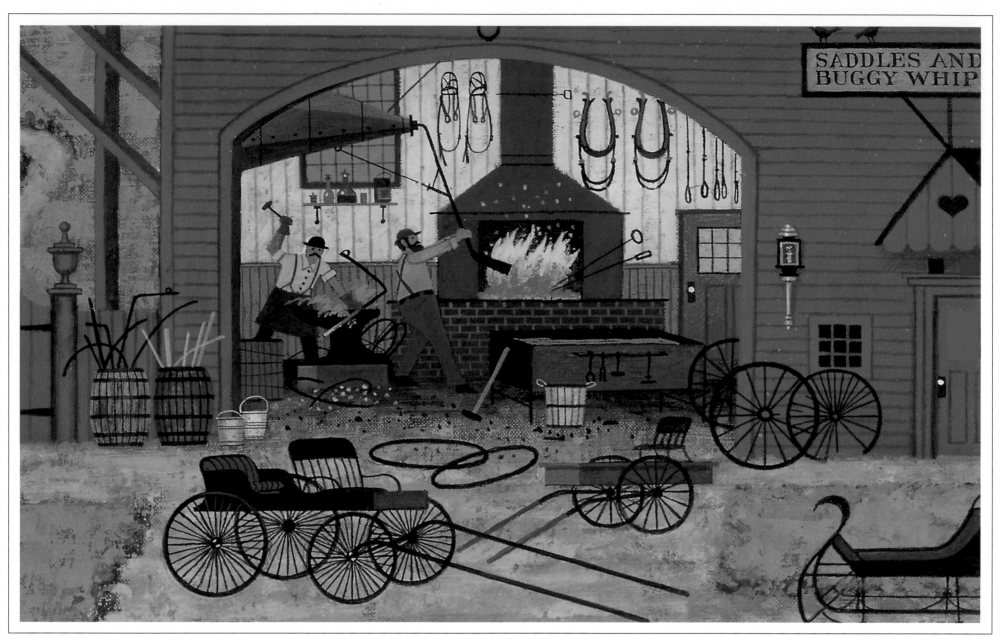

Caleb's Buggy Barn, detail

HEARTLAND

Charles Wysocki

Through the Eyes of a Child

For as long as I can remember, I have been blessed with a vivid imagination. As a child, I would spend hours staring out of the window. In school, the teacher would tap her pencil on the desk. Tap. Tap. Tap. "Wysocki, the classroom is in here." At home, my mother would ask me what I was looking at. "Pictures," I said.

Even then, I was seeing more than was out there to see. I was "making things up." These days it's called creative imaging. In that time and place, it was called daydreaming. It was my favorite occupation. The things I saw in my mind were as real as anything I could touch and much better because I could picture them exactly the way I wanted them to be.

Pretty soon I began to draw my daydreams. I drew the cars I wanted to drive, the airplanes I wanted to fly, the cowboy adventures I wanted to have. I drew in all the details. I put silver decorations on the cow-

Top center:
Chuck's children,
Matt, Millie,
and David

Our bush is Bristled
brown and grey,
A Christmas Snow has
nestled To Stay
The Love in This Home
we've found to stay
Will keep us Together,
so Warm and so gay.

16

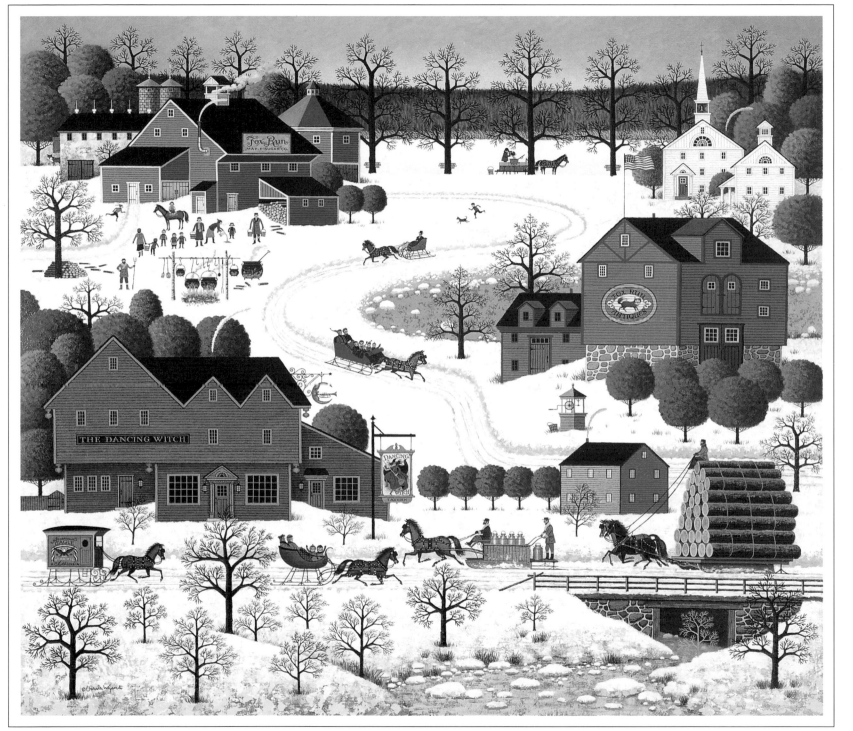

Fox Run

Dashing through
the snow
In a one-horse
open sleigh

Maple sugaring.
Pouring the syrup
on the snow.
Eating it like candy.
Can't you just
Taste it?

Why is the farm
called "Fox Run"?
Because there are
foxes out there.
How many? Where?

Why call a
wayside inn
"The Dancing Witch"?
Only a child
would know.

o'er the fields we go
Laughing all
the way.

BOY'S BELT. I GAVE HIM FRINGED
CHAPS AND A TEN-GALLON HAT. I MADE
SURE THE PILOT OF THE BIPLANE HAD
BULLETS FOR HIS GUN. WHEN I PICKED
UP A PENCIL OR CRAYONS AND BEGAN
TO DRAW (I CAN STILL SMELL THE
CRAYONS AND MANILA PAPER), I COULD
ALMOST FEEL MY LIFE TAKING A
DIRECTION. AT A VERY EARLY AGE,
I KNEW I WANTED TO BE AN ARTIST.

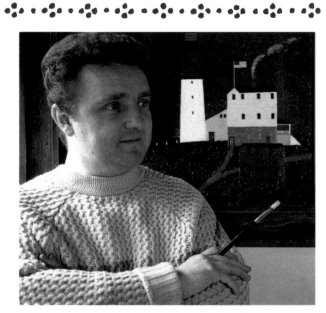

I LOVE
NEW ENGLAND

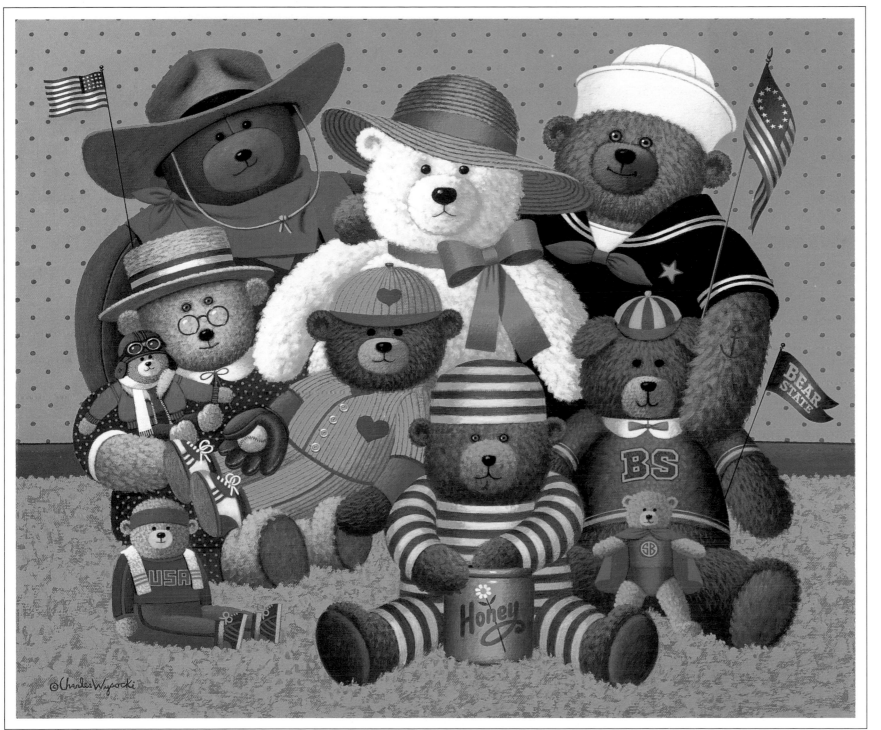

Frosty Winds and
Rosy-red faces
Happy the People the
Flirty Snow Chases

Here's snow that
is telling
of Landscapes just
swelling
and spreading white
schemes
of sweet Christmas
dreams

The Gang's All Here

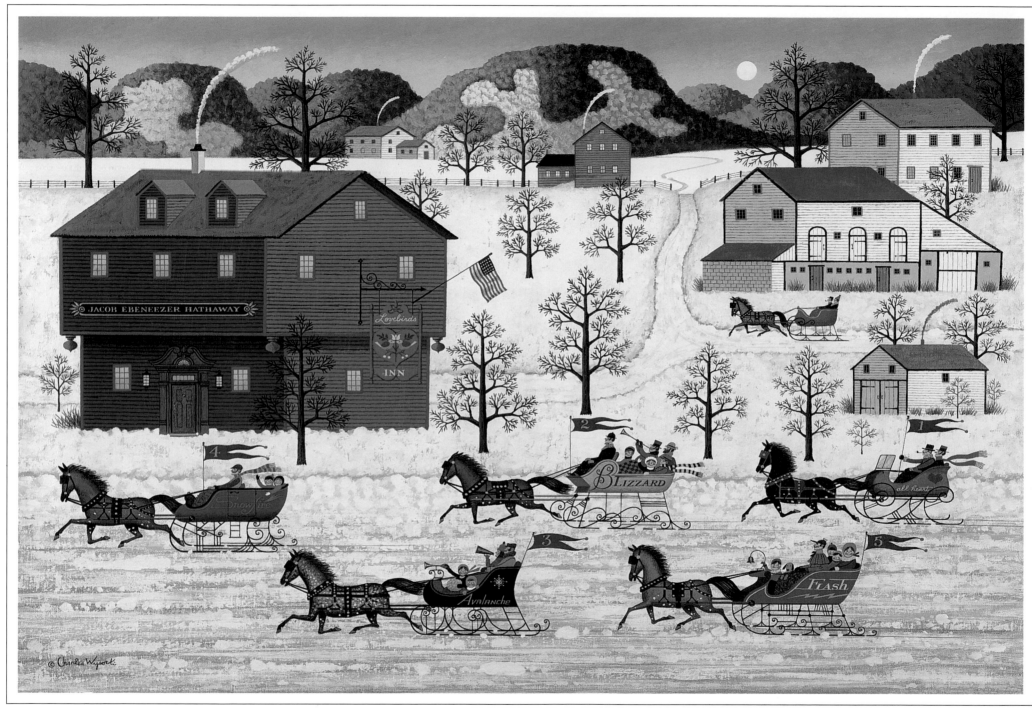

COUNTRY RACE

I LOVE OLD AMERICAN HOUSES, CROCKS, BOTTLES, JARS, PEWTER, BRASS, COPPER, QUILTS, CHESTS, WINDSOR CHAIRS, TAVERN TABLES, ♥ I LOVE SNOW, WIND, FLOWERS, AUTUMN, FIREPLACES, ROSY-CHEEKED CHILDREN, APPLE PIE, PUMPKINS, AMISH FOLKS, AMERICAN HISTORY, ♥ AND—

I LOVE NEW ENGLAND ♥ PENNSYLVANIA ♥ THE HISTORIC SOUTH

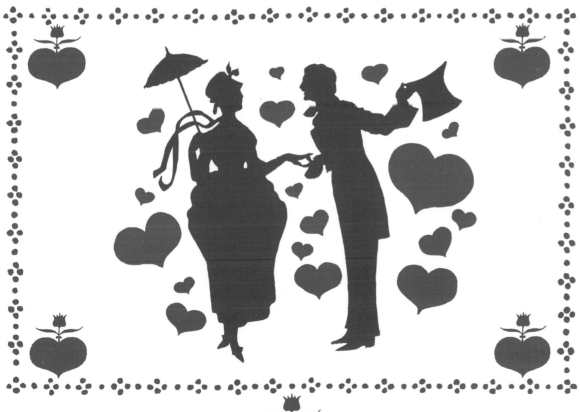

KIDS STUDY ALL THE LITTLE THINGS. THEY SAY TO ME, "EVERY TIME I COME BACK AND LOOK AT YOUR PAINTINGS, I FIND SOMETHING NEW." SOMEHOW, CHILDREN UNDERSTAND HOW IMPORTANT THE LITTLE THINGS ARE. IN ART. IN MARRIAGE. IN LIFE. MAYBE MY PAINTINGS TAKE A LITTLE LONGER BECAUSE I THINK ABOUT THE LITTLE THINGS THAT I PUT INTO THEM. I LIKE DOING PAINTINGS REMINISCENT OF MY YOUTH, AND THE LITTLE THINGS REMEMBERED THEREIN.

I GO BACK INTO MY CHILDHOOD FOR INSPIRATION BECAUSE CHILDHOOD IS FULL OF WONDER AND EXCITEMENT. SIGHTS AND SOUNDS AND FEELINGS ARE BRIGHTER AND SHARPER. YOU FEEL AS IF YOU'LL BURST WITH JOY, DIE OF DISAPPOINTMENT. IT'S A MAGICAL TIME. WHETHER OR NOT I PUT A CHILD IN THE PICTURE,

SOMETIMES I TRY TO COMMUNI-
CATE THE THRILL OF SEEING THE
WORLD THROUGH A CHILD'S EYES.
 I DIDN'T HAVE A PERFECT
CHILDHOOD; NOBODY DOES
BECAUSE IT ISN'T A PERFECT
WORLD. I DID HAVE A WONDER-
FUL CHILDHOOD BECAUSE I MADE
IT A WONDERFUL WORLD. TO
THIS DAY, I FEEL EACH PERSON
CAN MAKE HIS OR HER LIFE A
HEAVEN OR HELL. I CHOSE
BLUE SKIES AND WHITE CLOUDS.
I THINK PEOPLE HAD MORE
IMAGINATION THEN, BEFORE T.V.
ONLY RADIO AND BOOKS WERE

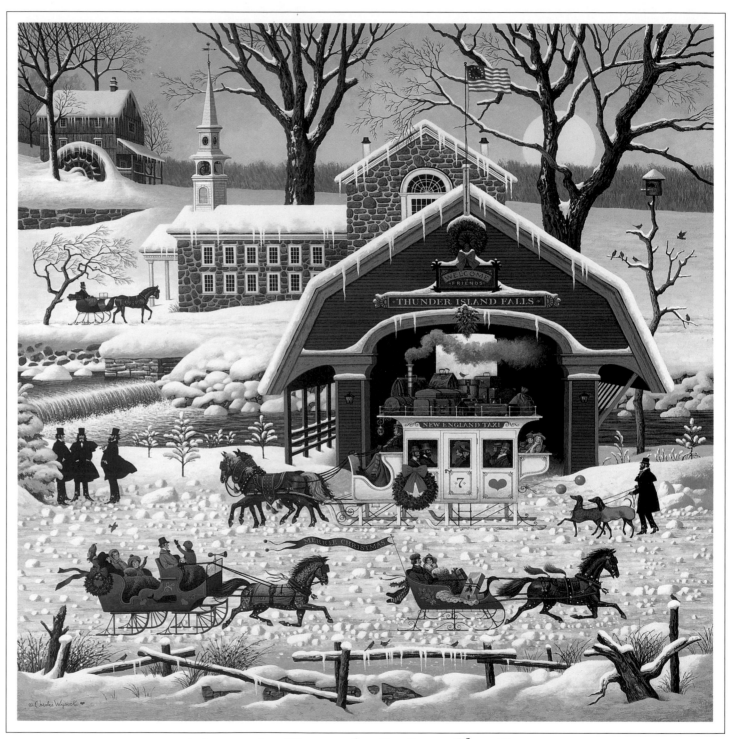

'Twas the Twilight Before Christmas

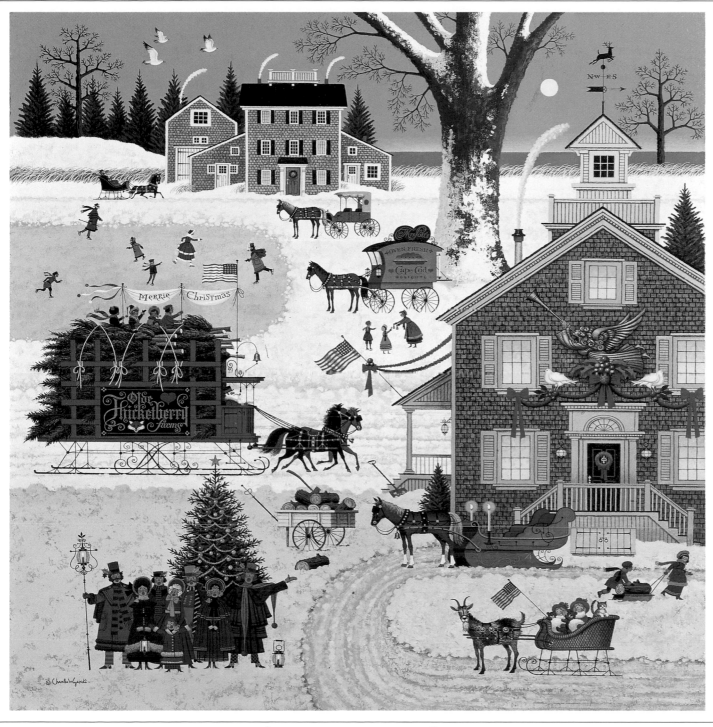

Cape Cod Christmas—1982 Christmas Print

MY FRIENDS, AND WHERE YOU MADE YOUR OWN PICTURES WAS IN YOUR MIND. IT WAS A STIMULATING TIME FOR YOUNG MINDS TO FLOAT.

TIMES WERE TOUGH IN DETROIT, WHERE I GREW UP IN A POLISH AMERICAN NEIGHBORHOOD. MY FIRST CHRISTMAS GIFT WAS A SACK OF OATMEAL. I WAS VERY HAPPY TO GET IT. I STILL LIKE OATMEAL.

MY HAPPIEST CHRISTMAS WAS WHEN I GOT MY FIRST SLED. I WAS STUNNED. THAT SLED WAS VERY, VERY DEAR TO ME. I ALSO GOT A CAP. I HAD SEEN THIS CAP IN A STORE

WINDOW—A HAT WITH GOGGLES ATTACHED. I THOUGHT I WOULD DIE IF I DIDN'T GET A CAP LIKE THAT. I SHOWED IT TO MY MOTHER BUT I KNEW I WOULDN'T GET IT. BUT I DID. AND A WHITE SCARF A MILE LONG. AND A

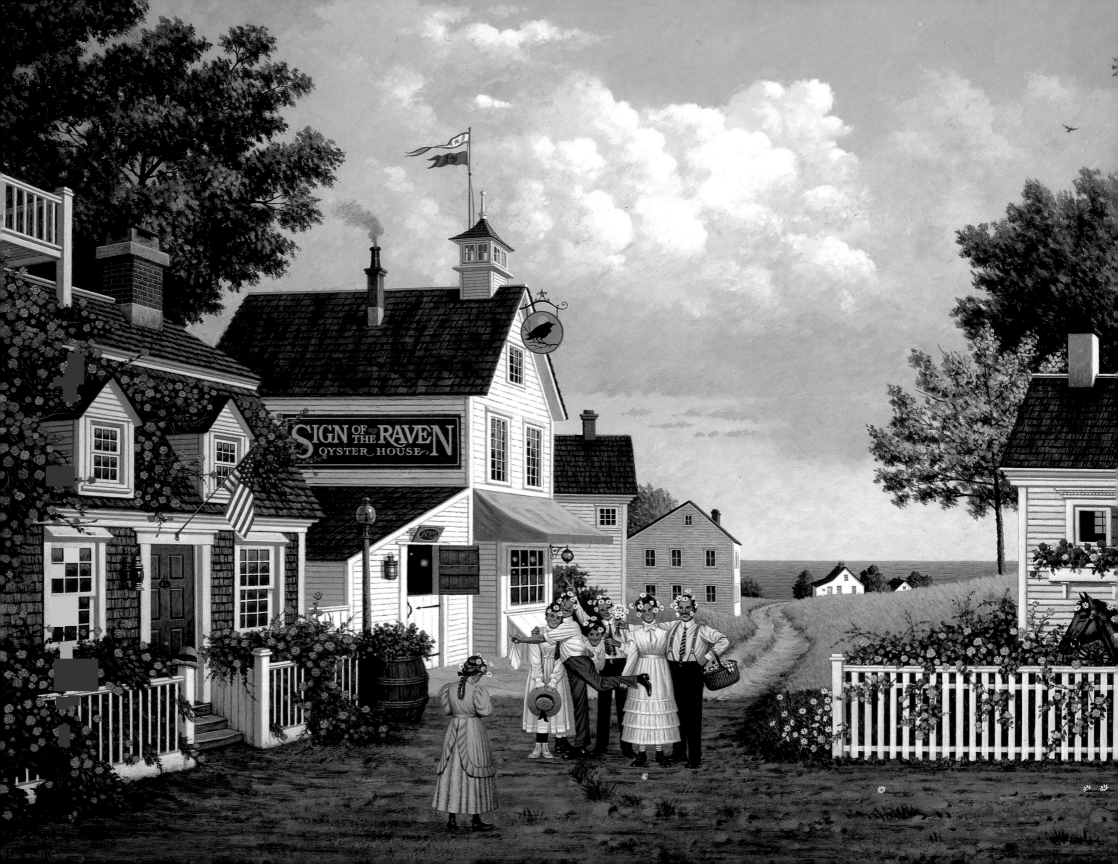

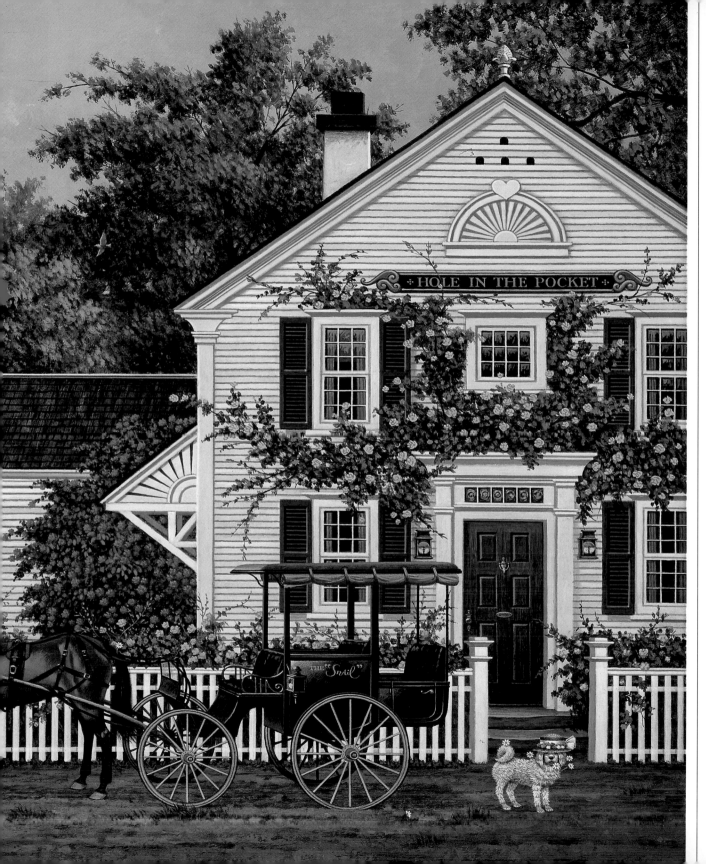

My home in Detroit!
We Rented the upper half
of this Home—We did Not Live
in Lower—this was Our
Landlord's Residence

Fun Lovin' Silly Folks

BONUS WAS A GIFT FROM MY
RICH AUNT—A LEATHER AND FUR
JACKET AND HIGH-TOP BOOTS
WITH A POCKET ON THE SIDE
FOR MY PENKNIFE. THIS
ENSEMBLE WAS MY WINTER
GARB, AND I WAS IN HEAVEN.
I WAS DEVASTATING AND READY
TO TAKE TO THE AIR ON MY

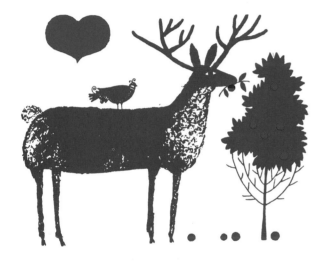

SLED. I PUT ON THE JACKET,
THE CAP, THE BOOTS, AND THE
SCARF AND RAN OUTSIDE AFTER
BREAKFAST. I RAN AND JUMPED
ON MY SLED AND SPENT ALL DAY
ON THE HILL. THERE WERE
FRIENDS WITH ME; I CAME IN
FOR COCOA AND RAN OUT AGAIN.
BUT IT SEEMED THAT THE
WHOLE WORLD WAS JUST ME
AND MY SLED AND THE HILL.

26

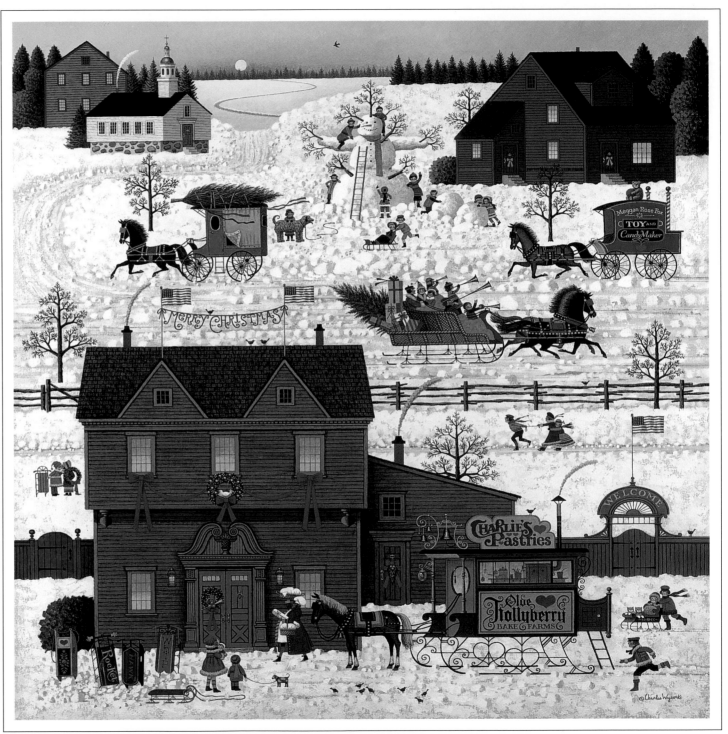

A Warm Christmas Love

Peace
17 02

Voices sing in yuletide cheer
Happy Mr. Partridge bird is here
To warble so mellow, a "hello",
Our Christmas guest, this fellow.

Love

Pink cheeks turned red
They slowly skate by
Young lovers spray ice
Together sparks fly

Hands locked in mittens
Warm glow in their eye
Hugs and caresses
Ardent hearts sigh

Gliding and spinning
The lovers waltz by
Whirling and twirling
Romantic darts fly

The moon showers a light
Their affection is high
It's dear sweet love
Touching hearts tie

Me and my sled and the hill
Me and my sled pass the mill
Me and my sled and the snow
Me and my sled on the go
Me and my sled everywhere
Me and my sled on a dare
Me and my sled on a tear
Me and my sled with no care
Me and my sled beat a hare

See my white scarf as I fly
Snow hitting my goggles on high
I'm the pilot of this ship; hear me sigh
With wings on my sled in the sky

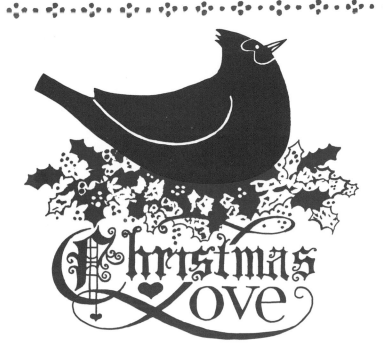

Christmas Love

The old house deep in snow

A FROZEN NEW ENGLAND DAY,
THE BARREN MAPLE SLOWLY SWAYS
AND SWEEPS THE COLD SKY GRAY.
THE RAGGED FIELDS OF BROWN HUM
WITH THE MOANING WINTER DEAD
AND TELLS THE FARMER IN A CHORUS
OF THE LONG COLD DAYS AHEAD.

1978

Through the snowy dark clouds I soar
Turn around and come back for more
And now I don't just laugh—I roar
See, it's not so bad being poor
I'm not doing bad without dough
Because rich is me
 and my sled and the snow

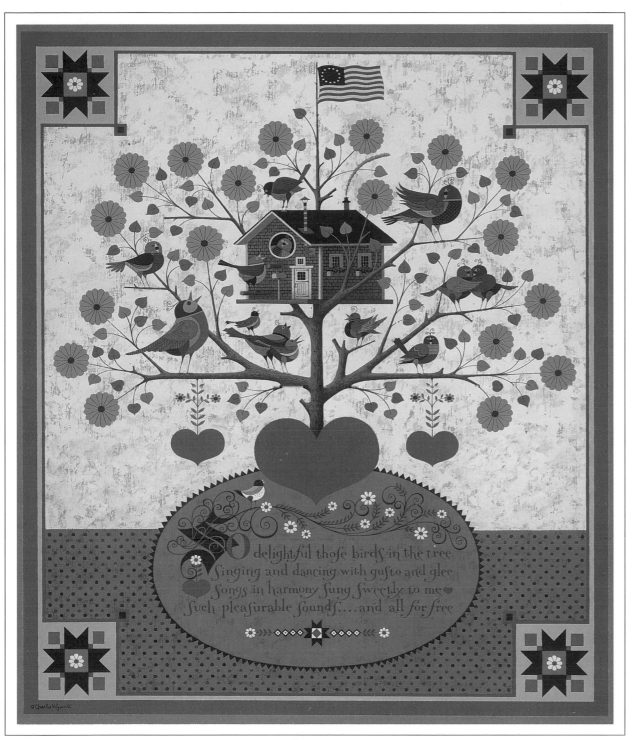

MERRYMAKERS' SERENADE

"...I have acquired a great admiration for the beauty of Early American art... I hope my paintings revive pleasant thoughts of a bygone era and express a semblance of order and serenity that fill a need in this fast changing world. I feel the greatness and beauty of America, and in it an endless source of inspiration for my paintings."

Those Christmas Kisses
That never Misses
To spread the blisses
How wonderful this is.

Jingle Bell
Teddy & Friends

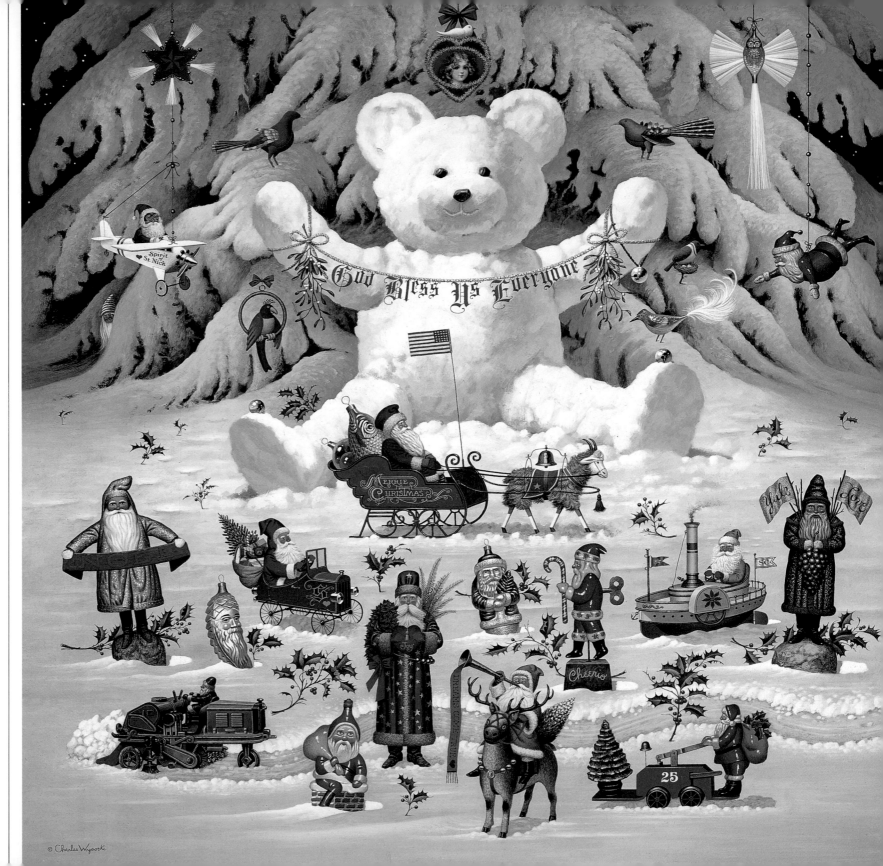

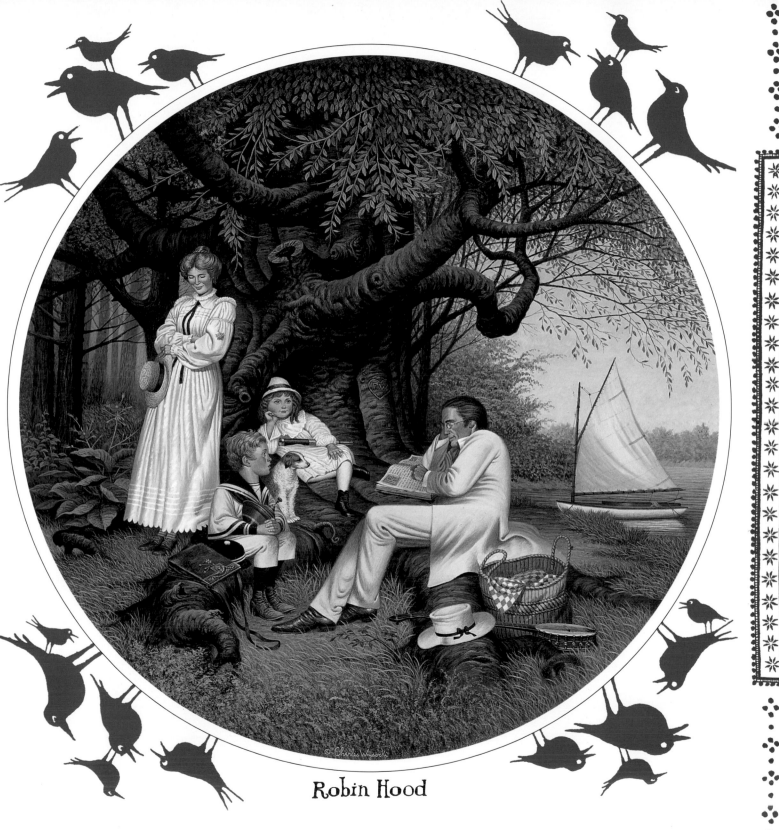

Robin Hood

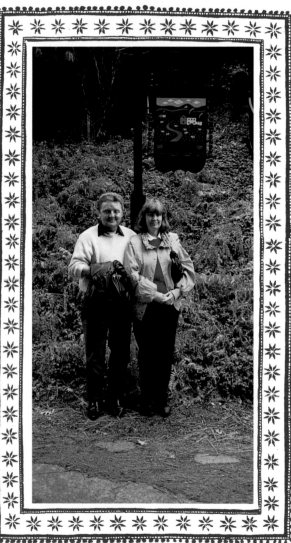

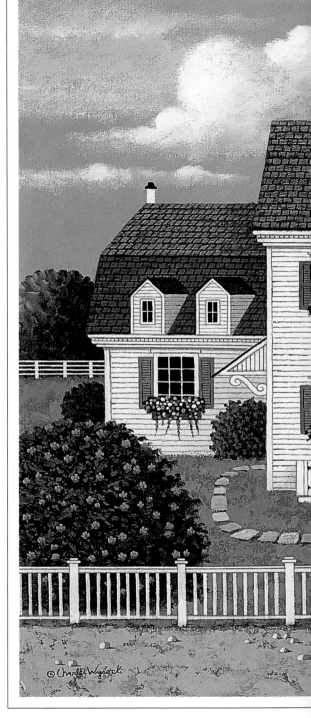

Charles Wysocki

- Born Detroit, Michigan ~ 1928
- Attended Cass Tech and School of Arts and Crafts in Detroit Also the Art Center School ~ Los Angeles.
- Paintings appeared in one man shows exhibited in National Galleries and world travelling shows.
- Holds over fifty awards ~ including the Dillon-Lauritzen Award.
- Lives and paints in southern California
- Collected internationally ~ private and business.
- Married: wife ~ "Liz" Children ~ "Millicent" "Matthew" "David"
- Collects early American primitive antiques.

A RARE collection of EARLY AMERICAN PAINTINGS by Charles Wysocki on display in the dining rooms May 17-1966 thru Sept 13-1966 Nut Tree California

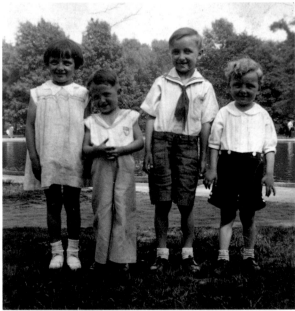

IT'S ME!

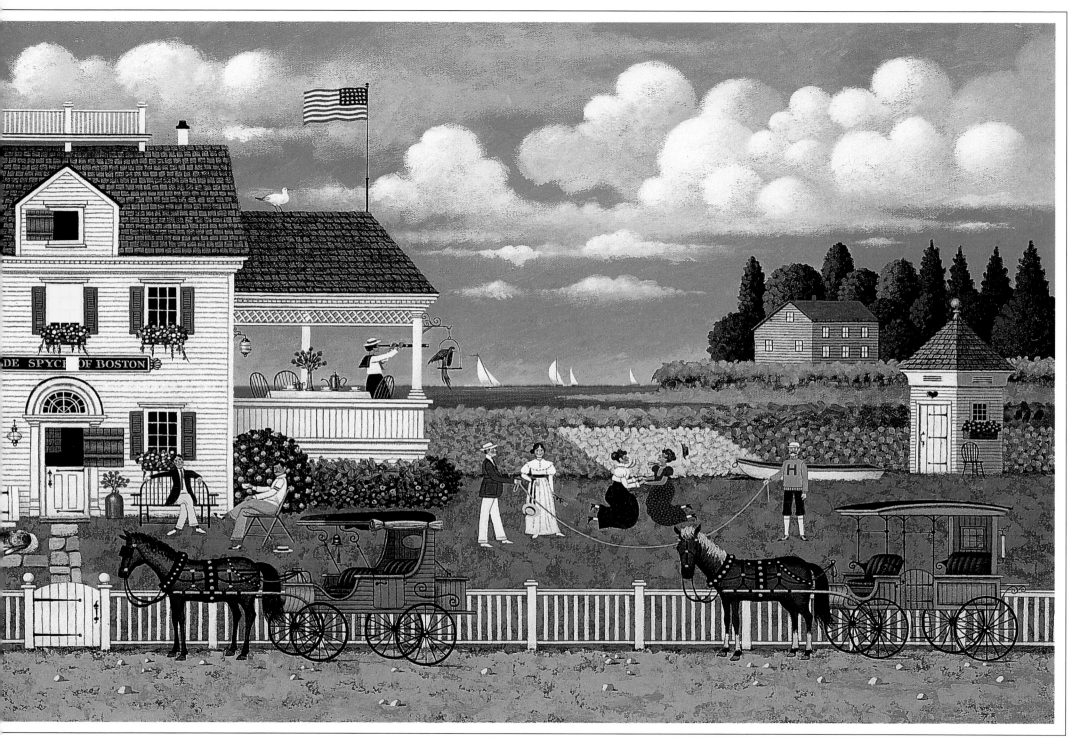

Tea by the Sea

THE BOUNTY of THE EARTH

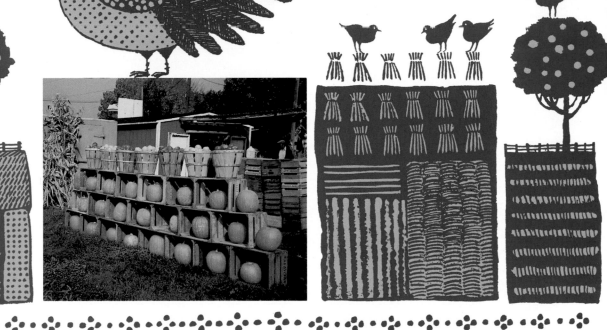

How did a city boy from Detroit, working in a Los Angeles advertising agency, come to devote most his life to painting early American country life? It could probably happen only in America and only through someone as remarkable as my wife, Elizabeth Lawrence Wysocki. Liz grew up on a farm in the San Fernando Valley. Her folks were one of the first families to settle in this part of California. They were chicken and turkey farmers,

The idea for Butternut Farms arose from a trip Elizabeth and I took to Bucks County, Pennsylvania, at the time of the Pumpkin harvest. We took loads of pictures. When I began to paint, I felt like a child again, giving myself more and more Pumpkins. I've never actually counted them. I wonder how many there are?

mutton or lamb beef or ham

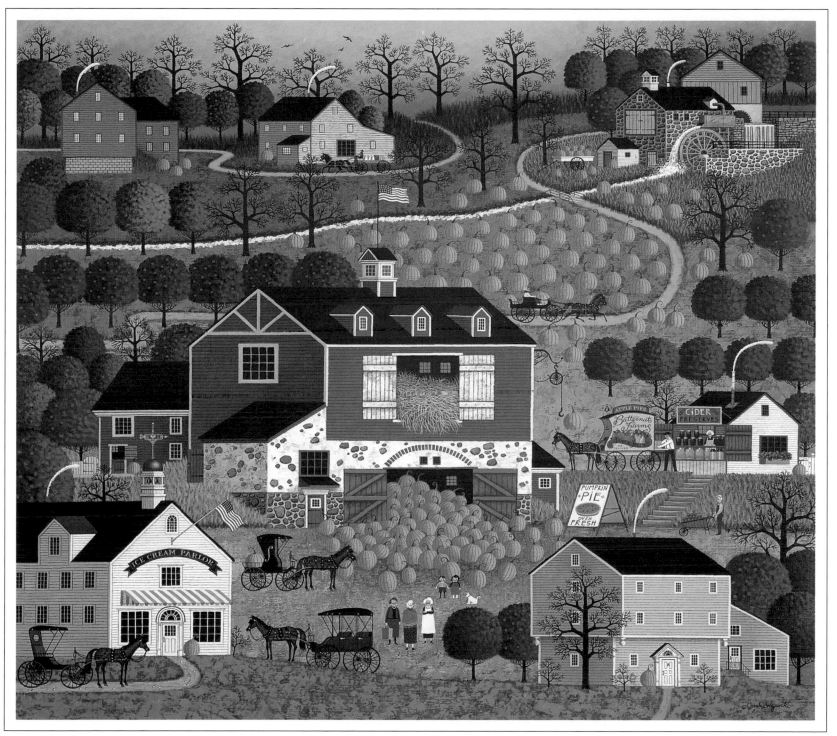

Butternut Farms

I Have No Thirst
Nor Sweet
 Tooth For Money
When The Land
 is So Full
Of Milk and Honey

Thy WORK
THE SOIL

THY WAGE
MORE TOIL

Thy LOVE
THE SOIL

APPLE BUTTER
MAKERS

36

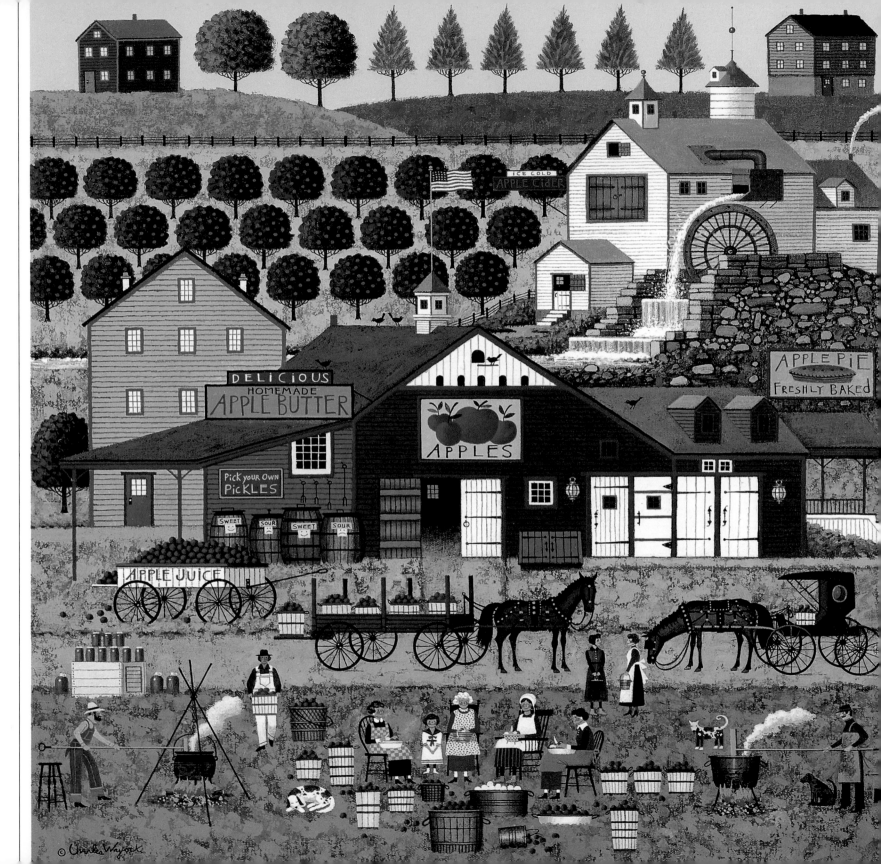

I LOVE

APPLES AND HEARTS STRUEDLES AND TARTS

THE PIG, THE PIG, THE CUTE LITTLE PIG
ATE A LOT AND GREW SO BIG
HOPPITY SKIPPITY JIGGITY JOG
NOW LITTLE PIGGY IS A BIG FAT HOG

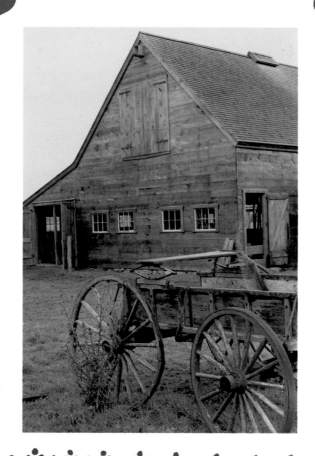

AND LIZ SPENT MOST OF HER LIFE IN OPEN COUNTRY. THE VERY FIRST TIME I WENT OVER TO DINNER AT THAT FARMHOUSE, I SAW HOW SIMPLY THEY LIVED AND HOW MUCH FUN THEY HAD. I BEGAN THINKING ABOUT PEOPLE LIVING A SIMPLE, COUNTRY LIFE, WORKING HARD BUT ENJOYING THE FRUITS OF THEIR LABOR, LOVING THE VERY SMALL, PERSONAL CLOSENESS OF EACH OTHER, HAPPY WITH LITTLE PLEASURES THAT CITY PEOPLE SEEM TO HAVE FORGOTTEN. LIZ ENCOURAGED ME TO TRY TO PUT THESE THOUGHTS AND FEELINGS ON CANVAS. MY FIRST EARLY AMERICAN PAINTING WAS OF THE LAWRENCE FARM.

FROM THIS BEGINNING, MY INTEREST IN AMERICANA HAS GROWN AND FLOUR- ISHED UNTIL IT IS NOW AN ENDLESS SOURCE OF INSPIRATION. IT IS NO ACCIDENT THAT SO MANY OF MY PAINTINGS REMIND VIEWERS OF NEW ENGLAND. ALMOST EVERY YEAR, LIZ AND I WANDER THE BACKROADS OF THE NEW ENGLAND STATES AND BUCKS COUNTY, PENNSYLVANIA, AND EACH TIME, MY MIND JUST LIGHTS UP. I REMEMBER OUR FIRST TRIP. I LOOKED AT THE WHITE CHURCHES AND COVERED BRIDGES AND THE BARNS AND THE OLD STONE MILLS AND I THOUGHT, "MY GOD, WHAT A BONANZA FOR AN ARTIST." ON OUR TRIPS NOW, I KEEP THE FAMILY BUSY TAKING SNAPSHOTS OF THINGS I WANT TO PAINT. BUT THE PHOTOS AND EVEN THE SCENES

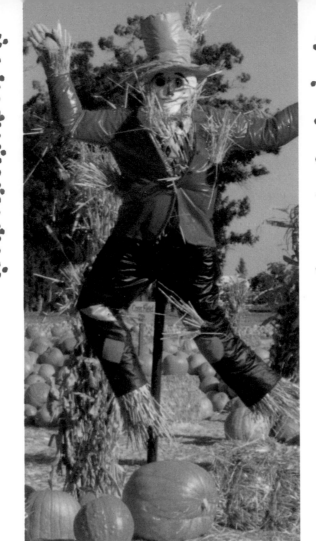

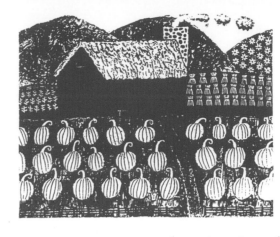

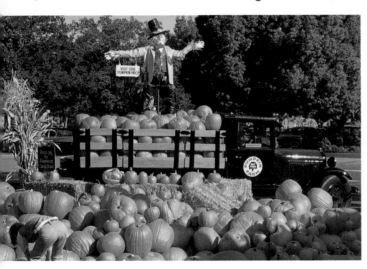

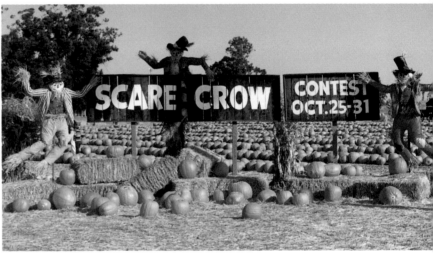

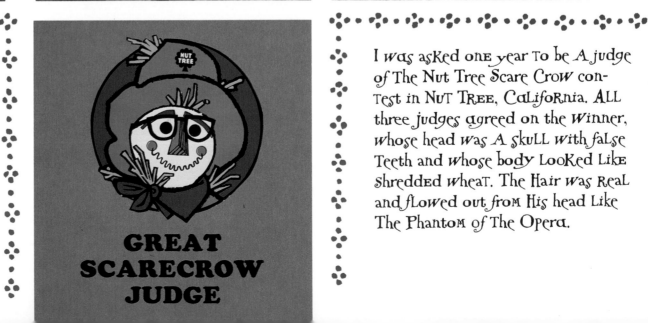

**GREAT
SCARECROW
JUDGE**

I was asked one year to be a judge of the Nut Tree Scare Crow contest in Nut Tree, California. All three judges agreed on the winner, whose head was a skull with false teeth and whose body looked like shredded wheat. The hair was real and flowed out from his head like the Phantom of the Opera.

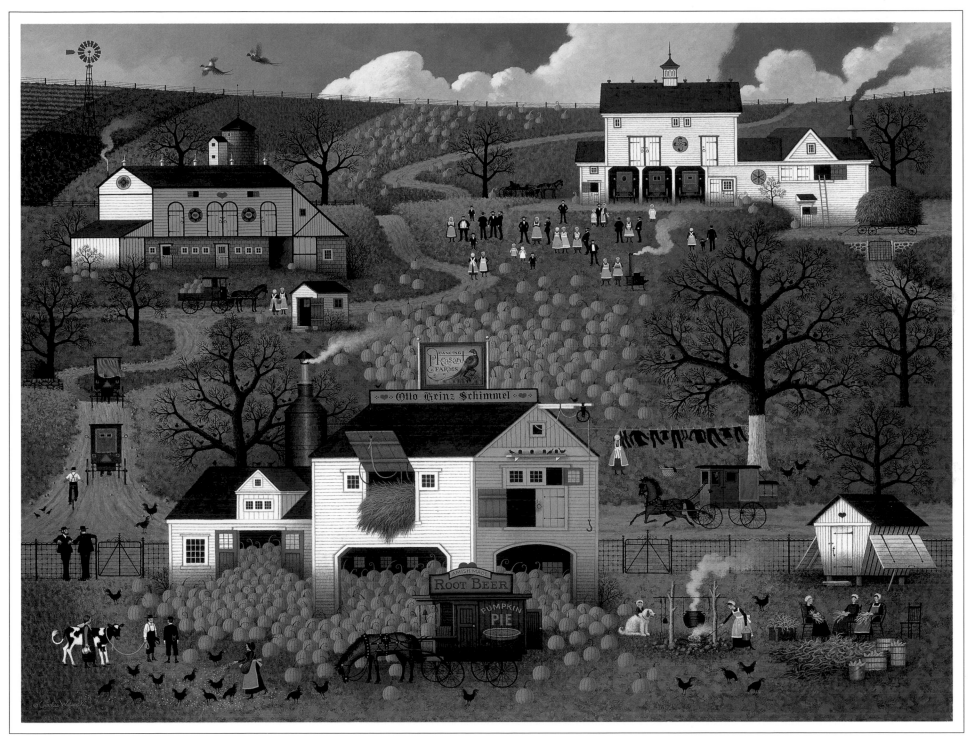

Dancing Pheasant Farms

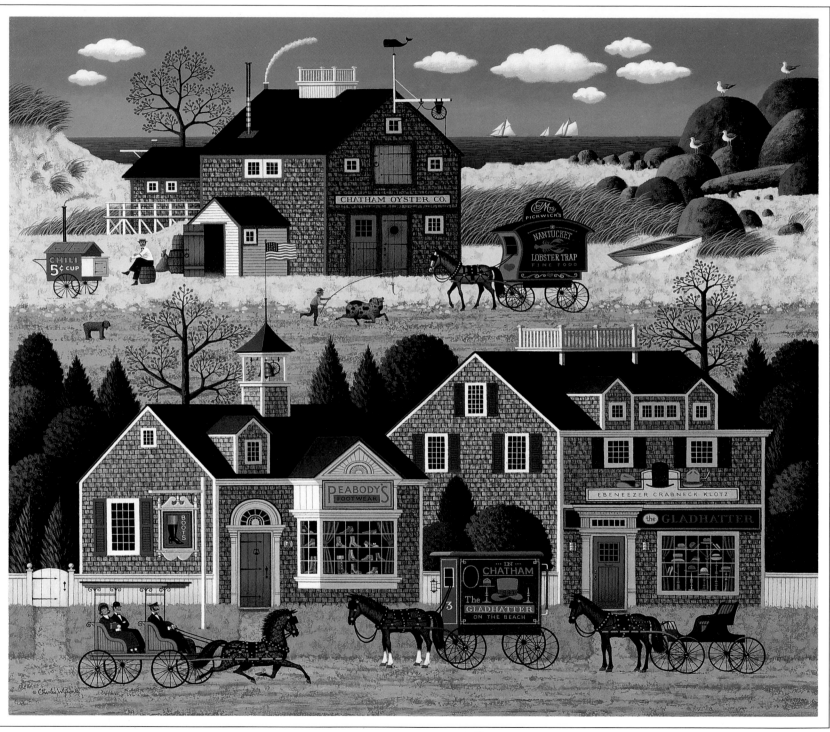

Devilstone Harbor

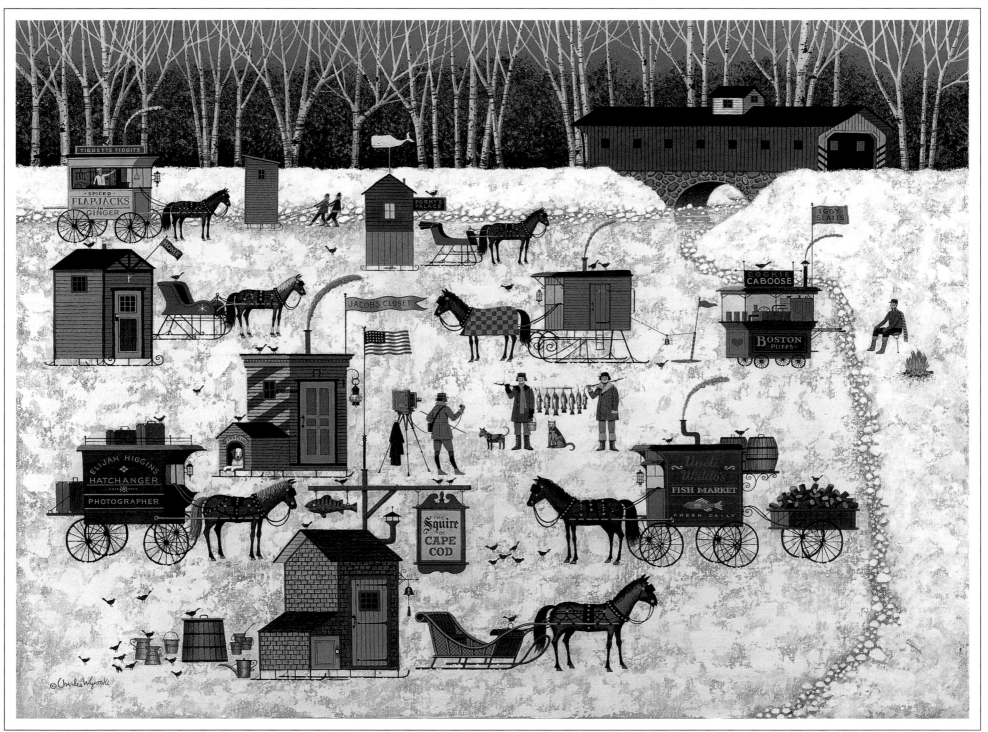

Cape Cod Cold Fish Party

A Bountiful year
is such a delight!
No need to curb
the Appetite.

A picnic, a Song,
good things To eat,
Indoors or out,
Make Life a Treat.

Amish Neighbors

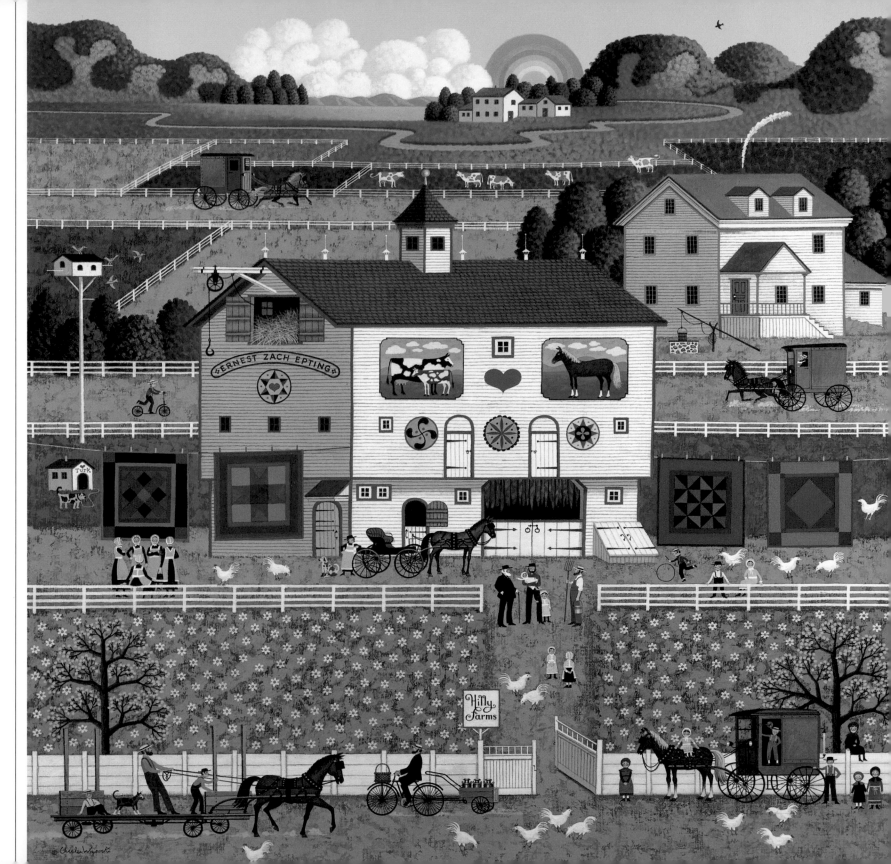

THE SNOW CAME LAST NIGHT
AND THE DOOR IS FROZEN TIGHT
THE SOUP IS IN THE POT
THE FIRE IS COZY AND HOT
A PLACE IS AT THE TABLE
COME IN IF YOU ARE ABLE

PUMPKIN HOLLOW
Dr. Livingwell's Balsam
For ALL Ailments-Snakeoil

THE OX WITH THREE TAILS IS LOVED WITH A PASSION
HIS SOUP BRINGS HAILS AND IS QUITE THE FASHION

HARVEST

WE PHOTOGRAPH ARE JUST A BACK-
GROUND FOR THE STORIES I WANT TO
PAINT—STORIES OF PEOPLE WORKING AND
PLAYING, LOVING AND LAUGHING, BUSY AND
HAPPY IN THEIR ACTIVITIES, GETTING A
KICK OUT OF LIFE.

I LOVE PAINTING THESE EARLY AMERI-
CAN SCENES, BUT I NEVER CON-
SIDERED MYSELF A PRIMITIVE PAINTER.

I WAS TOO "SCHOOLED" TO CLAIM THAT
NAIVE WAY OF EXPRESSING MYSELF.
MY ART SCHOOL TRAINING LEADS ME TO
GIVE A GREAT DEAL OF THOUGHT TO
COMPOSITION IN TERMS OF CAREFUL PLACE-
MENT OF EACH ELEMENT. I DON'T PARK
A BUGGY JUST ANYWHERE OR STREW
PEOPLE AROUND AT RANDOM. FOR

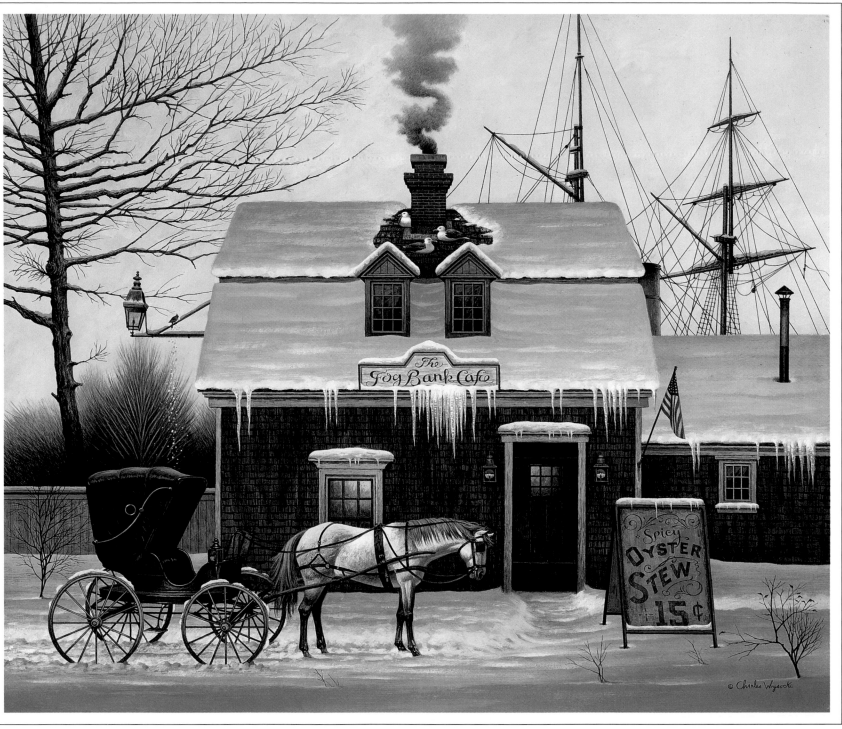

BELLY WARMERS

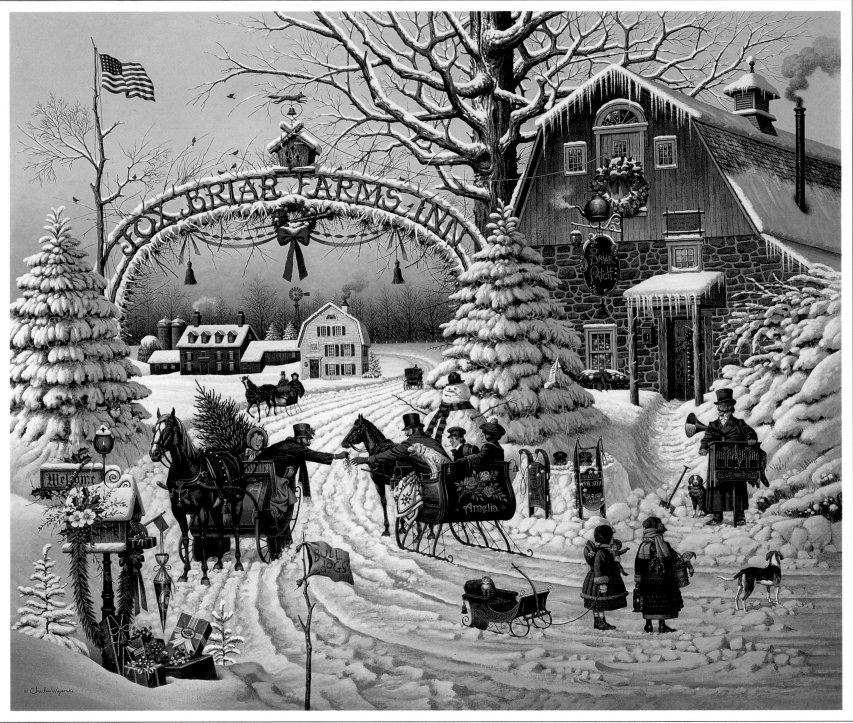

Chestnuts, Popcorn,
Jellies and Jams
Candy Canes,
Snowballs,
Holly and Hams.
Fruitcakes, Mistletoe,
Sighs and Ties.
Santa Claus, Apples,
Kisses and Pies.

Christmas Greetings—1989 Christmas Print

Jars, jugs, bottles and crocks,
Square-head nails and grandfather clocks,
Chickens, cows, horses and pigs,
Plums, pumpkins, apples and figs.
Joys from the farm we love all year,
This is our home, small and dear.

JoLLy HiLL FaRms

46

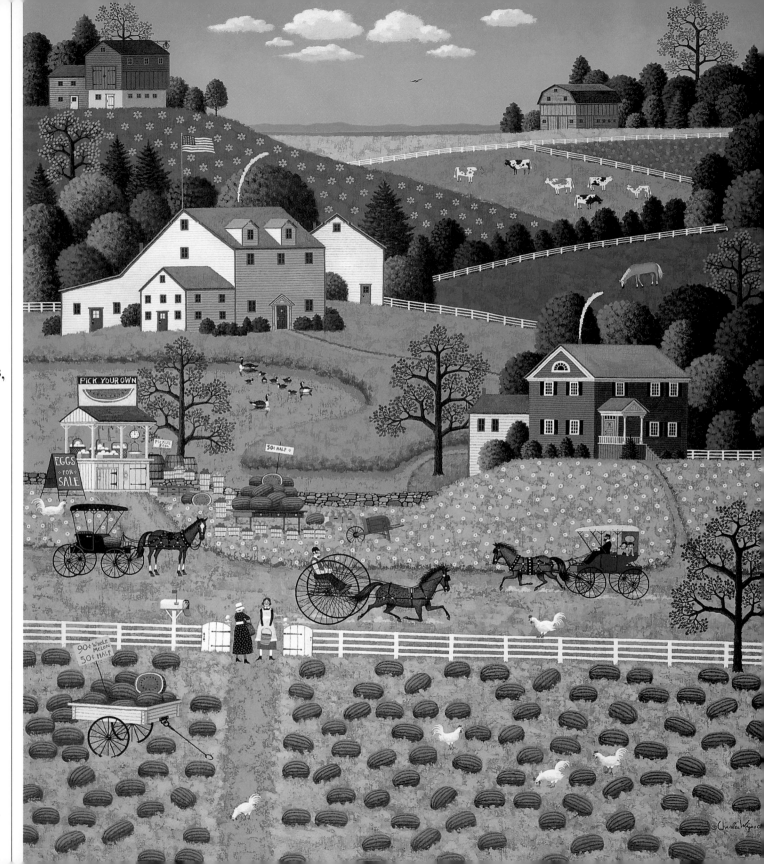

EXAMPLE, I LIKE TO PAINT PEOPLE IN THREES—FOR DESIGN PURPOSES AND SO THEY CAN HAVE A NICE CONVERSATION. ALWAYS THESE TWO THINGS—STORY AND DESIGN—ARE IN MY MIND WHEN I DO A PAINTING.

I THINK PEOPLE ENJOY MY PAINTINGS BECAUSE I ALWAYS TRY TO DO THINGS THAT WILL REALLY BE FUN AND A CHALLENGE FOR ME. AND I PAINT FOR AS LONG AS IT TAKES TO MAKE ME SOMEWHAT SATISFIED. FIRST I SATISFY MYSELF, AND THEN HOPEFULLY THE ONLOOKER WILL

HE CHEWS AND EATS AND MEALS IN THE BOWERS

THE FAT LITTLE LAMB WHO TASTES LIKE THE FLOWERS

THE EGGMAN

CONVERT TO FISHING SHACK

EGGS BROWN WHITE LARGE·SMALL

Nut Tree Pumpkin Patch OPEN PICK YOUR OWN PUMPKINS

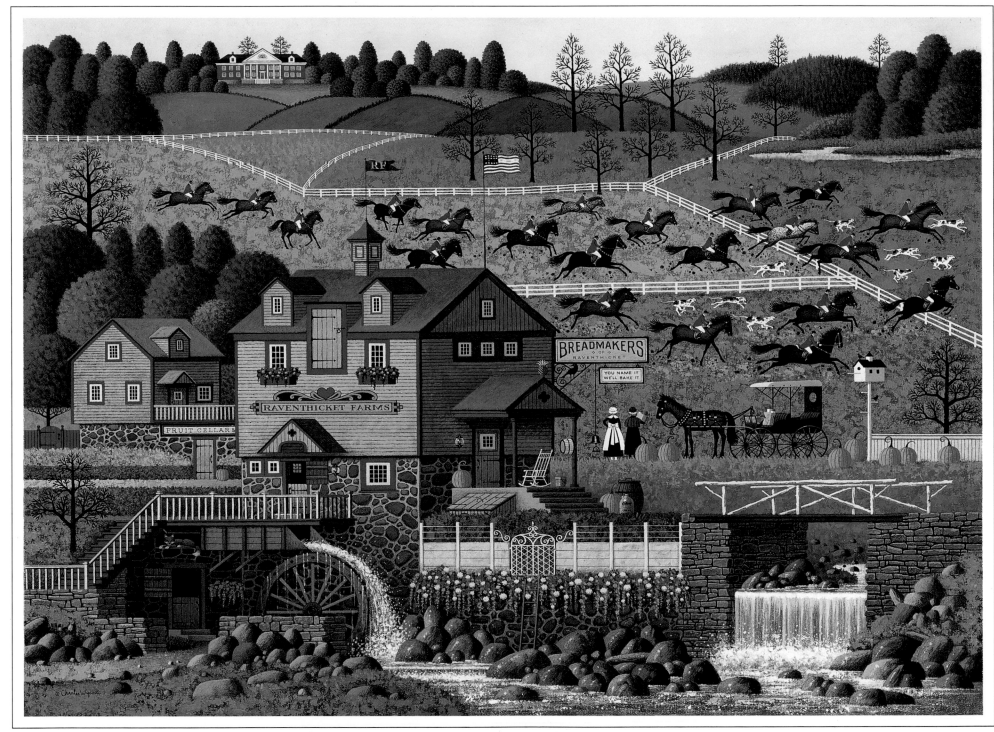

The Foxy Fox Outfoxes The Fox Hunters

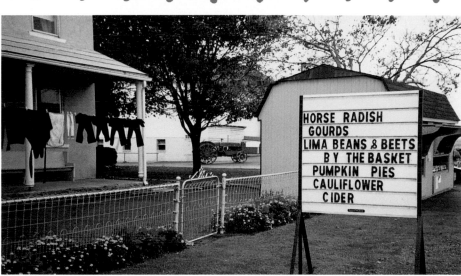

HORSE RADISH
GOURDS
LIMA BEANS & BEETS
BY THE BASKET
PUMPKIN PIES
CAULIFLOWER
CIDER

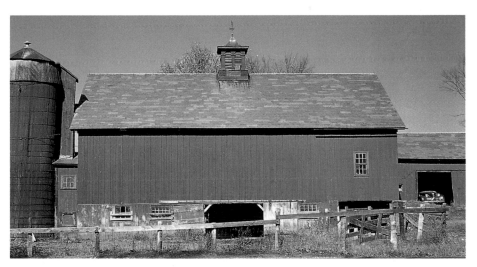

Eat, Drink and Enjoy The Earth
And Feed your Love
For all You're Worth.

49

FEEL THE SAME. I HOPE MY RENDITIONS WILL SEEM REAL TO PEOPLE, SO THEY CAN IMAGINE THEMSELVES THERE, IN MY WORLD.

AS A CHILD, I LOVED DRAWING BECAUSE I COULD HAVE ANYTHING I WANTED. I DIDN'T

HAVE TO DRAW JUST ONE PUMPKIN, I COULD DRAW A DOZEN. I COULD DRAW A BARN FULL OF PUMPKINS. I COULD DRAW THE WHOLE FARM. I STILL FEEL THAT FREEDOM WHEN I PUT A CANVAS ON MY EASEL.

Sunset Hills, Texas Wildcatters

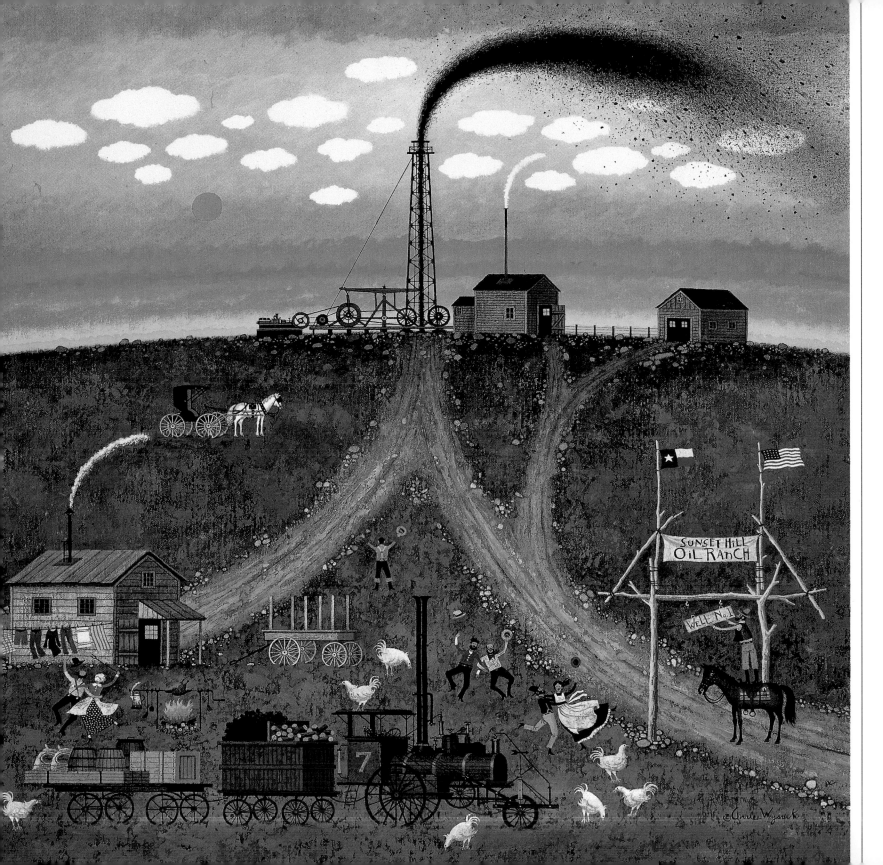

51

THE CHARM of AMERICA

I LIKE THE HISTORY OF OUR COUNTRY, THE TERRAIN, THE CHARM OF THE SMALL TOWNS, AND THE SEACOAST. I LIKE NEW ENGLAND. I LIKE ITS OLD VALUES, ANTIQUES, OLD HOUSES, THE PEOPLE AND THEIR SMALL BUSINESSES. ALSO THE WONDERFUL CHANGE OF SEASONS. I LIKE THE WEST, THE DESERT, COWBOYS, COWGIRLS, LEATHER, LIZARDS, CACTUS, AND THE WIDE RANGE OF COLOR, FROM THE REMARKABLE SUNSETS AND SUNRISES TO THE VERY SUBTLE DRIED PLANT LIFE. I LIKE THE LEGENDS AND SOUVENIRS OF THE GOLD RUSH. SINCE ALL OF THE LOCALES IN MY PAINTINGS ARE CONCEIVED AND CREATED BY ME, YOU WILL NOT SEE AN ACTUAL SITE OR LOCATION IN MY WORK. I PAINT ALL OF THE BEAUTIFUL THINGS THAT AMERICA IS. PAINTING ACTUAL SITES IS TOO CONFINING AND, I FEEL, RESTRICTS MY CREATIVITY.

I LIKE STRUCTURES, ESPECIALLY ALL VARIETIES OF NEW ENGLAND ARCHITECTURE, AND I INCORPORATE

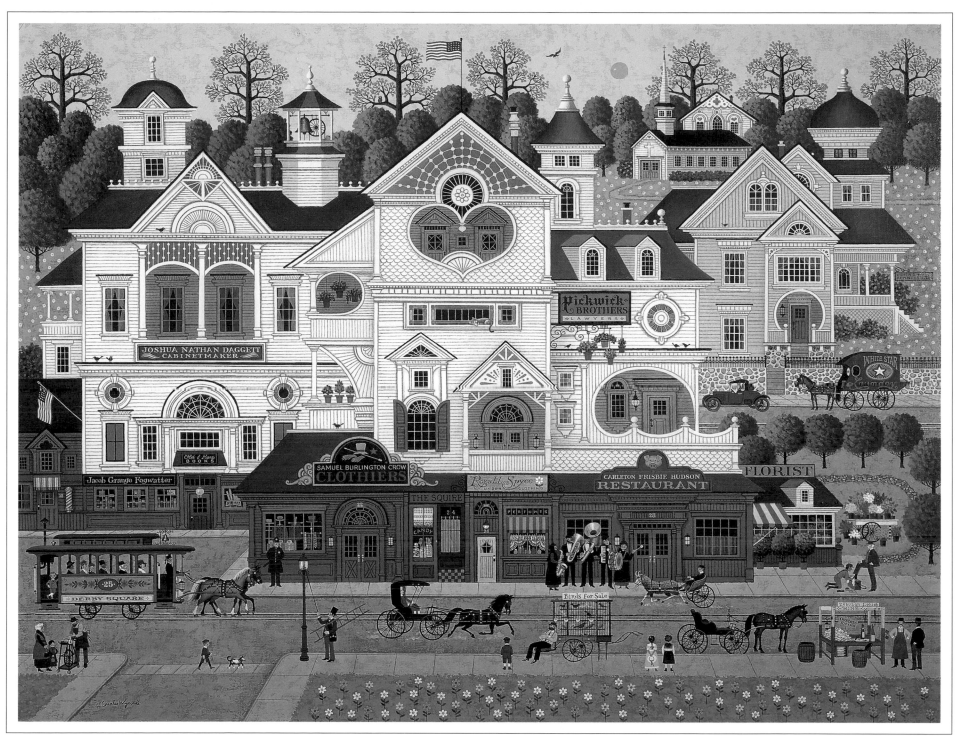

Derby Square

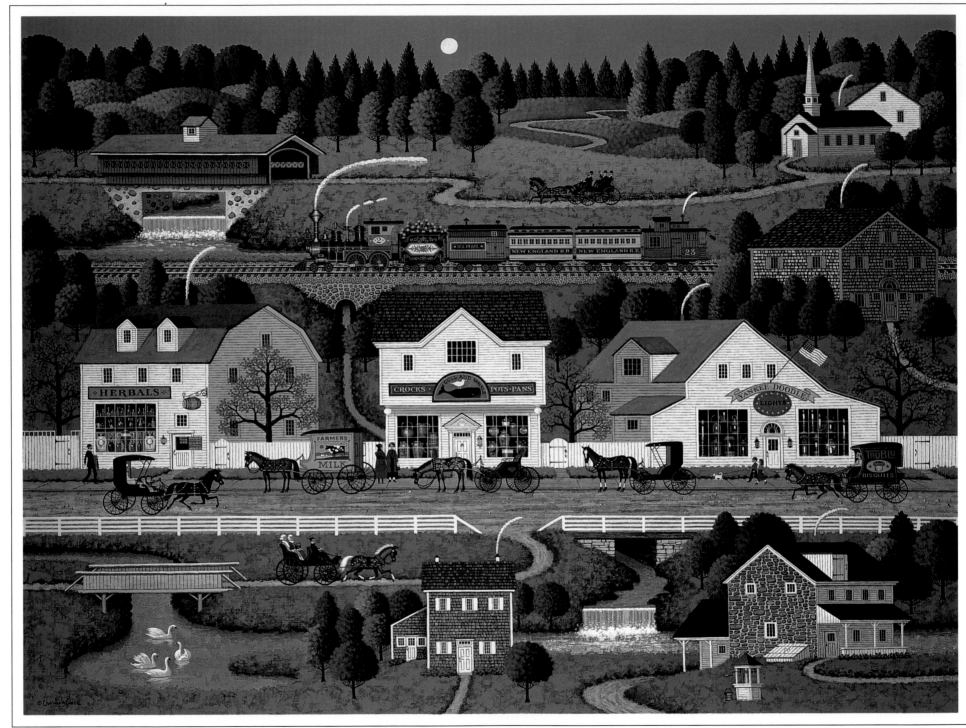

Yankee Wink Hollow

EARLY AMERICAN PAINTINGS

THESE IN MOST OF MY PAINTINGS.

I HAVE A HUGE LIBRARY OF REFERENCE BOOKS, POSTCARDS AND CLIPPINGS RELATING TO THE PARTS OF OUR COUNTRY I WISH TO PORTRAY. BESIDES THAT, I MAKE NUMEROUS

TRIPS TO THOSE AREAS TO GET THE FEEL OF THEM, THAT CERTAIN CHARM. I'M VERY SELECTIVE ABOUT THE PHOTOGRAPHS I TAKE. I DON'T TAKE SHOTS OF LARGE, EXPANSIVE SCENES. I DIRECT MY ATTENTION TO THE LITTLE THINGS LIKE LAMPPOSTS, GATES, SIGNS, FENCES, WALKWAYS, BRIDGES, DOORWAYS, FLOWER GARDENS. THE BUGGIES AND EQUIPMENT IN MY PAINTINGS ARE DESIGNED BY ME, AS ARE THE HOUSES AND ALL OF THE OTHER STRUCTURES—ALL WITH A COLONIAL FEELING. I USE PHOTOS ONLY

Dr. Bonkley - VETERINARIAN

WHITE'S ART STORE
2315 HONOLULU AVE. MONTROSE, CALIF.

THE BIRD HOUSE

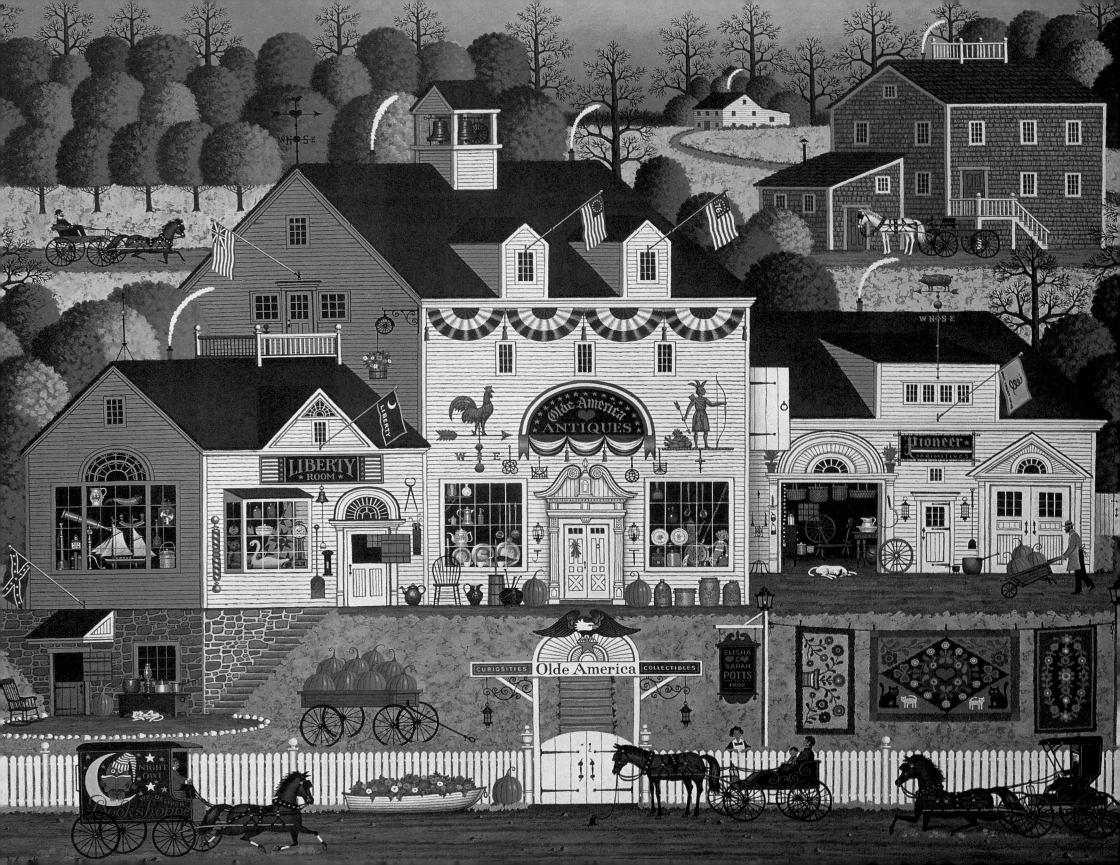

FOR REFERENCE. I DON'T TAKE A PICTURE AND DUPLICATE IT AS A PAINTING BECAUSE THIS PROCESS _LEAVES OUT_ A VERY IMPORTANT ELEMENT—_ME!_ I WANT TO HANG _MY_ PERSONALITY AND _SOUL_ ON THE WALL, GOOD OR BAD, SO PEOPLE CAN SEE ME AND NOT A MECHANICAL RERUN.

THERE ARE ARTISTS WHO PAINT PICTURES FROM PICTURES THEY HAVE

TAKEN. THERE ARE ARTISTS WHO TAKE PICTURES AND STRETCH THEIR IMAGINATIONS WITH THEIR PERSONAL OBSERVATIONS AND COLLECTIONS OF ELEMENTS TO _CREATE_ THEIR OWN PAINTINGS.

LIZ AND I GO TO NUMEROUS ANTIQUE STORES, SHOWS, AUCTIONS, BOOKSTORES, AND FLEA MARKETS AND SUBSCRIBE TO ALL FORMS OF ART AND ANTIQUE

PUBLICATIONS. THERE IS MUCH FERTILITY HERE IF YOU GET HOOKED, AND THIS FORM OF REALIZATION HAS ENRICHED MY ART AND MY LIFE IMMEASURABLY. I OBSERVE, COLLECT, AND APPLY. WHEN STAYING IN SMALL TOWNS,

I HEAD FOR THE LOCAL BOOKSTORE. IT USUALLY HAS A BOOK OR TWO ON THE HISTORY OF THE TOWN AND THE NAMES OF PAST OWNERS OF BUSINESSES AND PEOPLE OF NOTE. OFTEN THESE FOLKS HAD A FIRST NAME, A MIDDLE NAME, AND

Yukon Outfitters Hdqtrs.
Pete's Gambling Hall
Willie Magpie French,
Gunsmith
Blacksmith & Horsecare

Ironbelly's Saloon
The Rawhide Club
Tillie's Liberty Bakery
Kirby's Well
Tex 'N' Tillie's

EAST
WEST

58

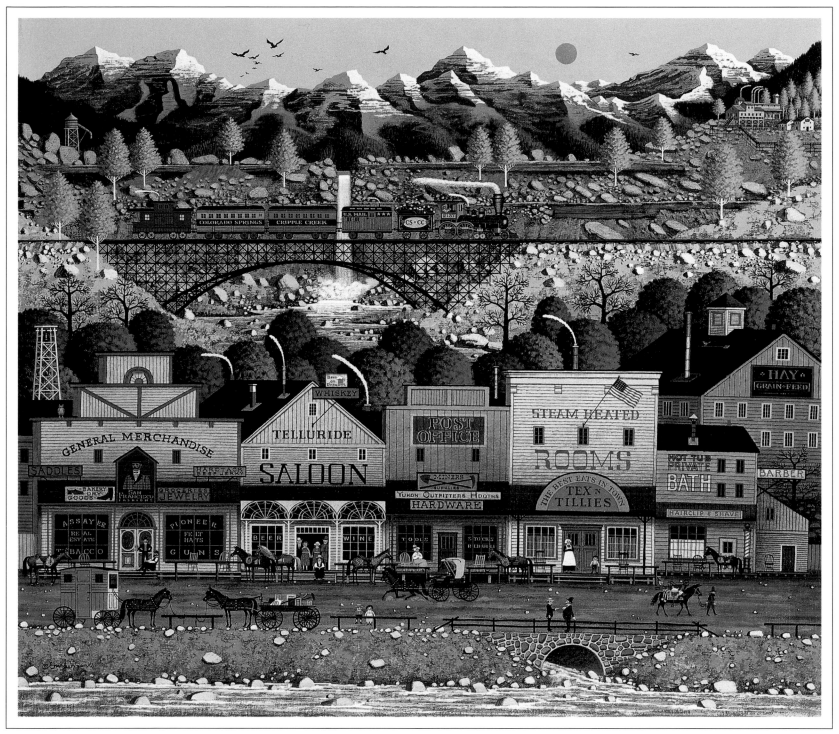

Sleepy Town West

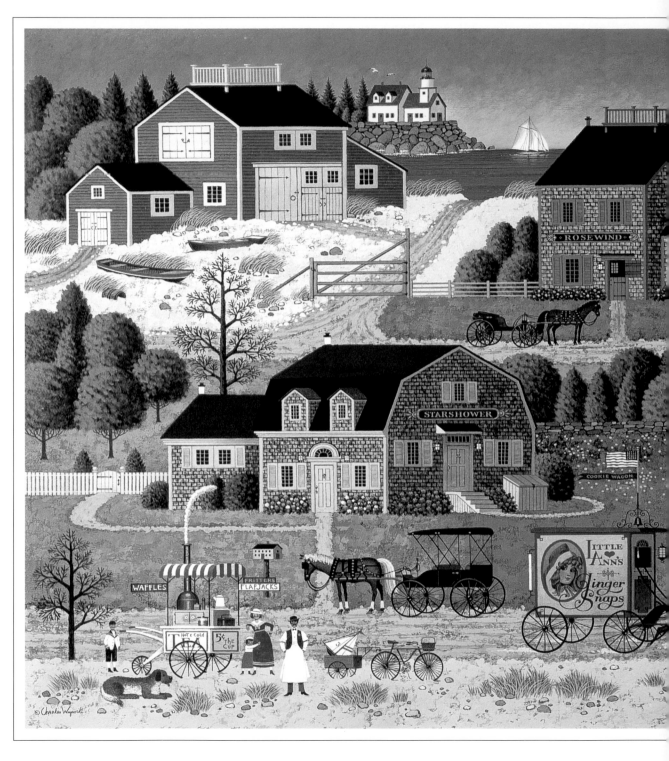

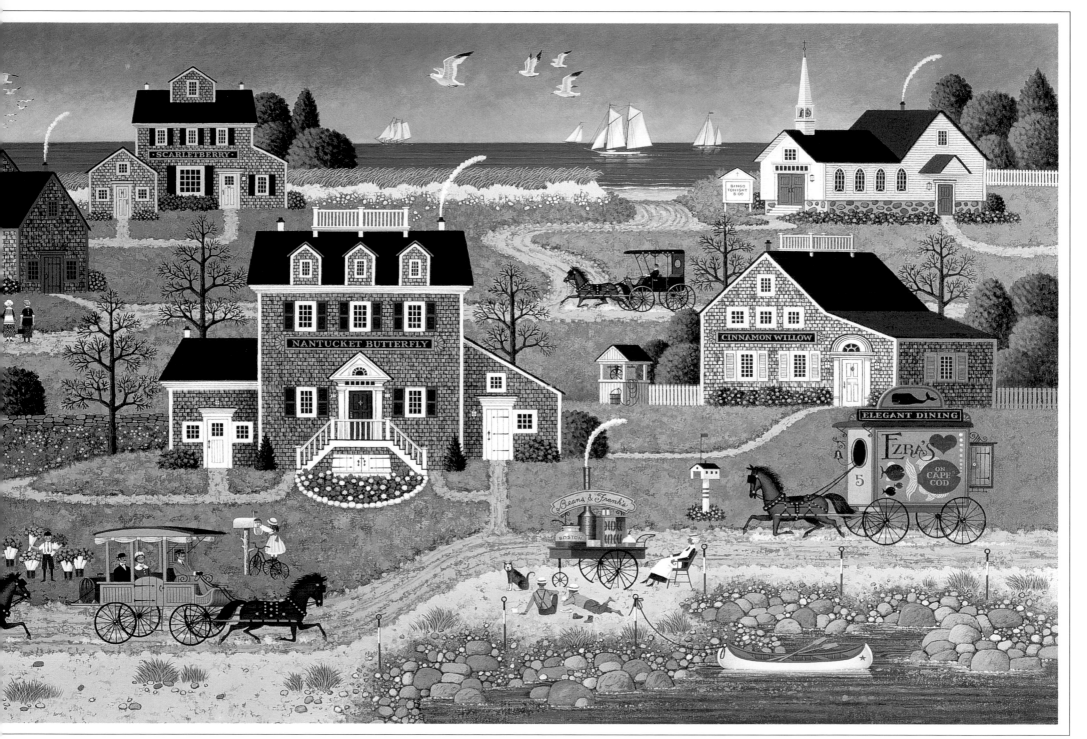

Salty Witch Bay

A LAST NAME AND WERE REFERRED
TO BY ALL THREE. THESE OLD NAMES
HAVE A NICE RING TO THEM AND I LIKE
TO INCORPORATE THEM IN MY PAINTINGS.
 I HOPE TO FIND FUN IN THE NAMES
I MAKE UP FOR STOREFRONTS, SIGNS,
BUGGIES, AND WAGONS AND THE
SITUATIONS I SET UP THAT HAVE THEIR

ELEMENTS OF HUMOR. IT'S NOT BELLY
LAUGH, ROLL 'EM IN THE AISLES I'M
LOOKING FOR. I SEE HUMOR IN THE
SMALL THINGS: A SIGN ON A HEARSE:
"PITHIA'S BLOODLUST WRINKLEDEATH,"
A SIGN ON A HOTEL IN A HALLOWEEN
PAINTING: "ROOMS TO FERMENT."
 WHEN I PAINT A BAKERY, I CAN'T
RESIST THINKING UP SWEETS THAT
SOUND AS GOOD AS THEY TASTE.

Barclay Farms Bakery

Just Singing and baking
And eating and Making
Sweet rolls for The Taking
For folks who are Waking.

BEEHIVE BAKERY
WE ARE BIZZY
BIZZZY
BIZZY

VELVET KISSES
YANKEE SNAPS
BLUEBERRY GRUNTS
MARBLEHEAD CHIPS
INDIAN JOHNNYCAKES
JOLLY BOY'S
GINGER WALNUT MUFFINS

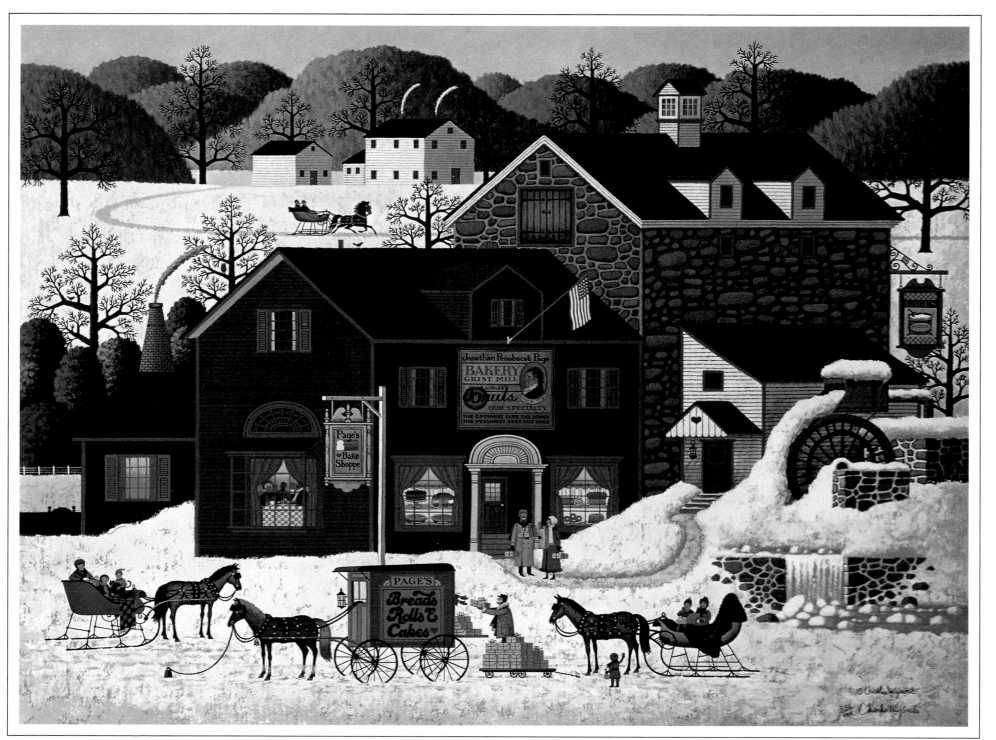

Page's Bake Shoppe

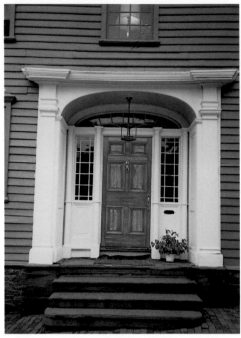

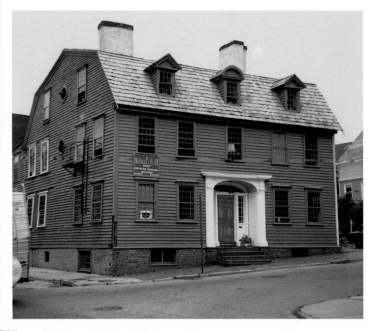

Prairie Wind Flowers

64

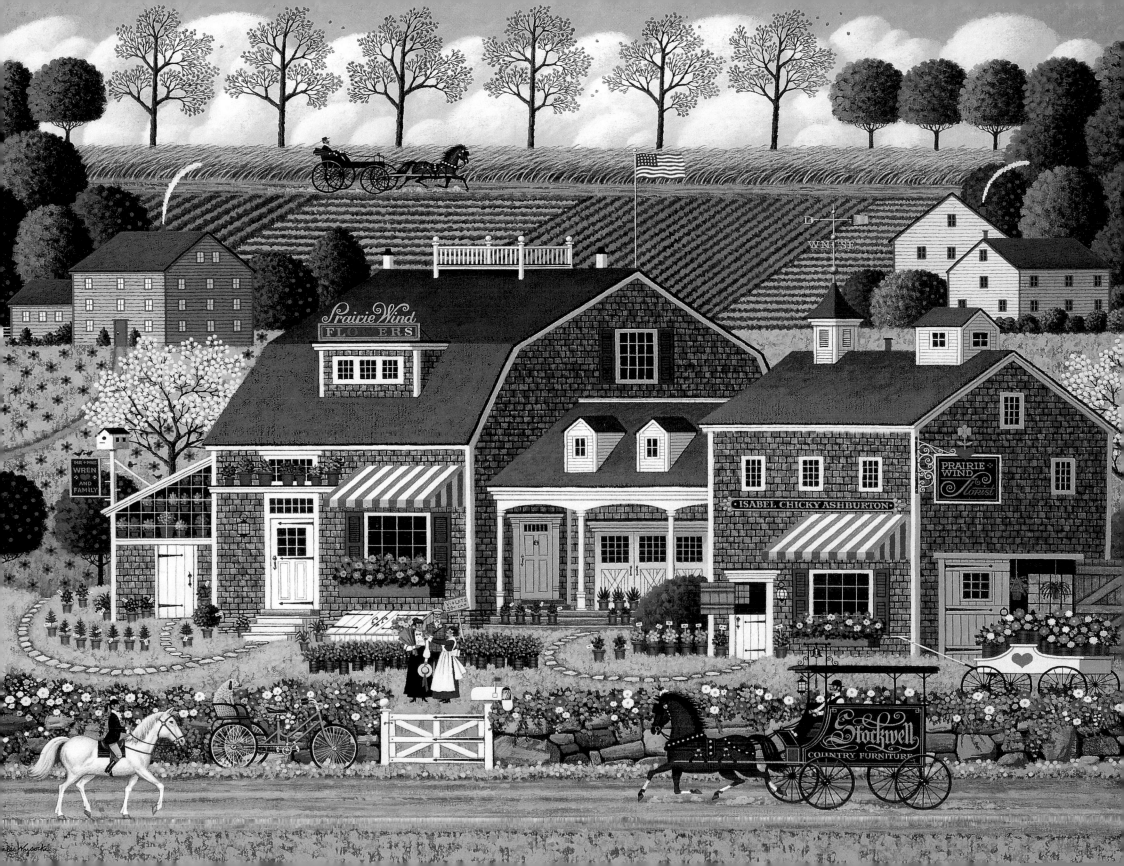

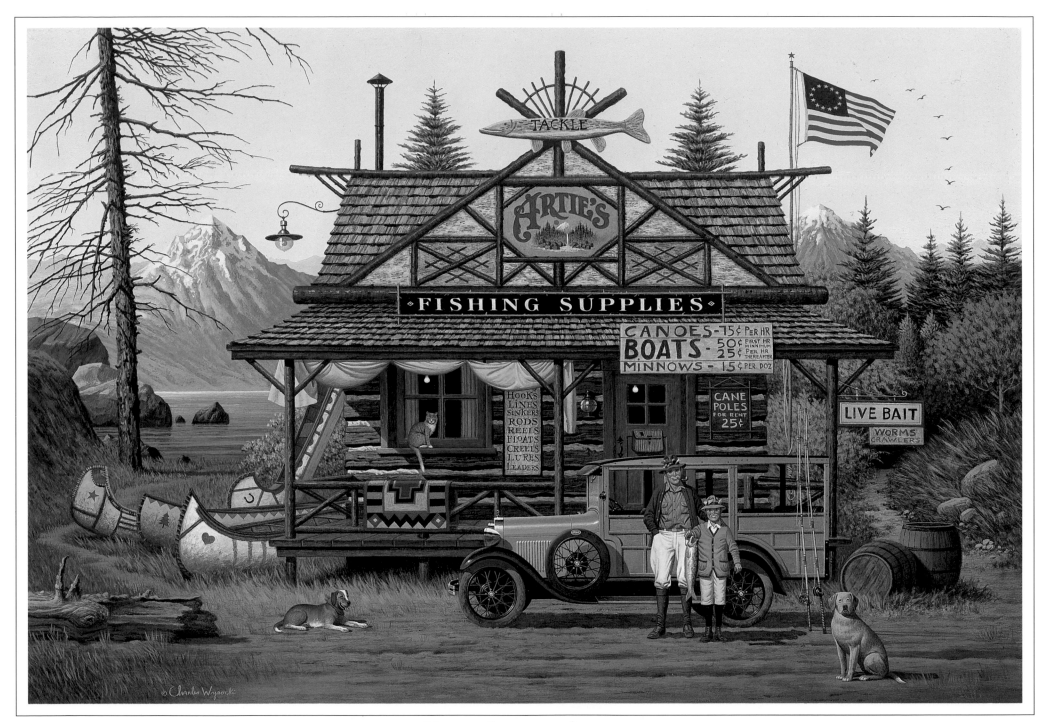

Proud Little Angler

BRICK

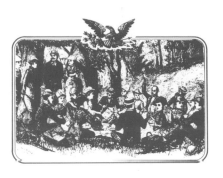

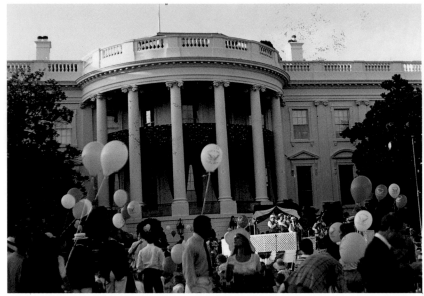

JULY 4, 1981
AT
THE WHITE HOUSE

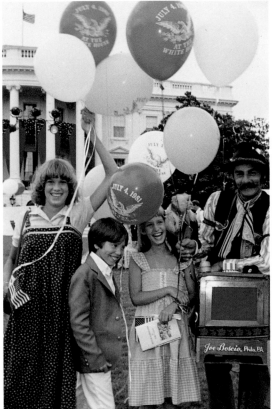

Joe Boscio, Phila, PA

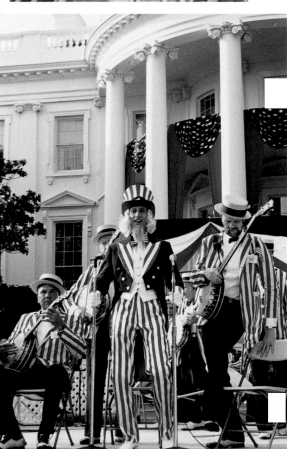

THE WHITE HOUSE

WASHINGTON

November 29, 1984

Dear Mr. Wysocki:

Nancy and I want to thank you for your very
special gesture. Your fine painting, "White
House July 4th Picnic," will indeed be a wel-
come addition to our Presidential collection
and the friendship which prompted your thought-
fulness means more than we can say. Our first
Independence Day celebration at the White
House was truly memorable and your work is
a most fitting remembrance of the occasion.

With our deep gratitude and our heartfelt
best wishes to you and Mrs. Wysocki for the
coming holiday season,

Sincerely,

Ronald Reagan

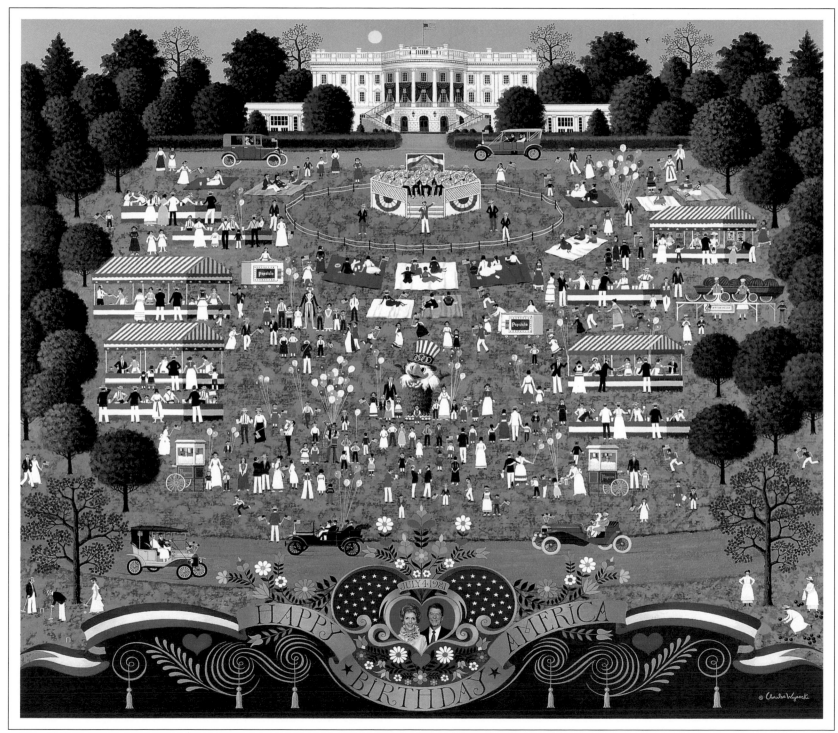

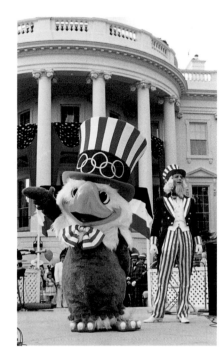

The White House 4th Of July Picnic

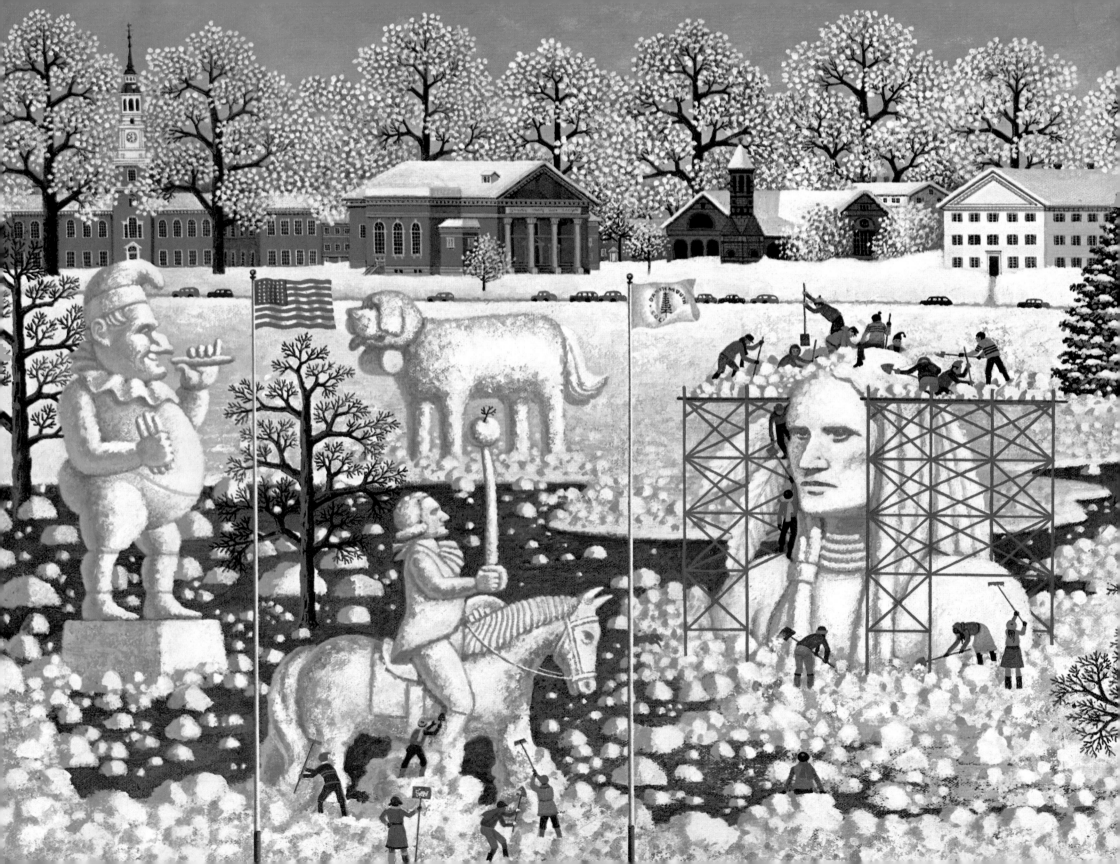

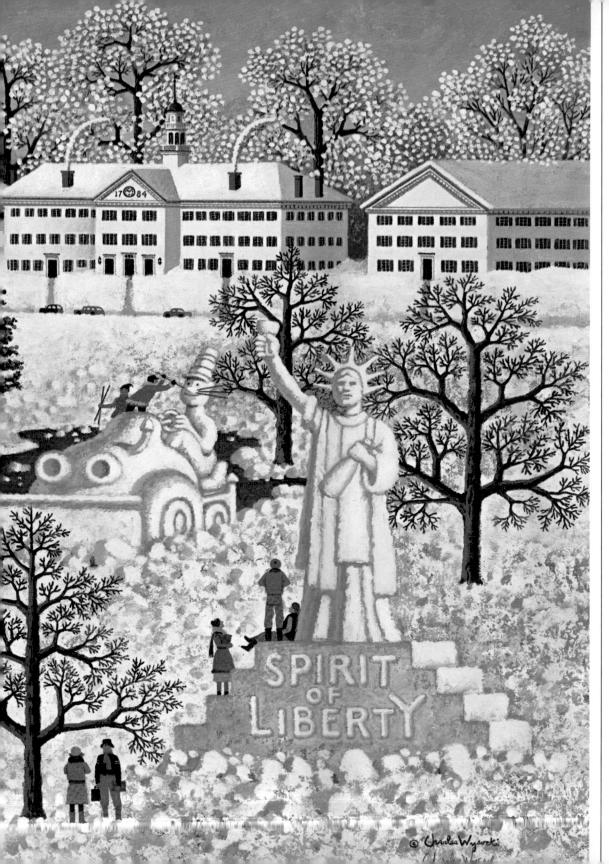

Ah! The Winter has come at Last
The icy winds and Snowy blast.
Christmas whispers its Arrival soon
Fireside songs with a Heavenly Tune.
The Beautiful Snow so thick in The storm
Flakes play and dance and wildly fly
The scene from My Window, Quiet and warm
As the blanket so white finally Rests on the rye.

Carnival Cupers

71

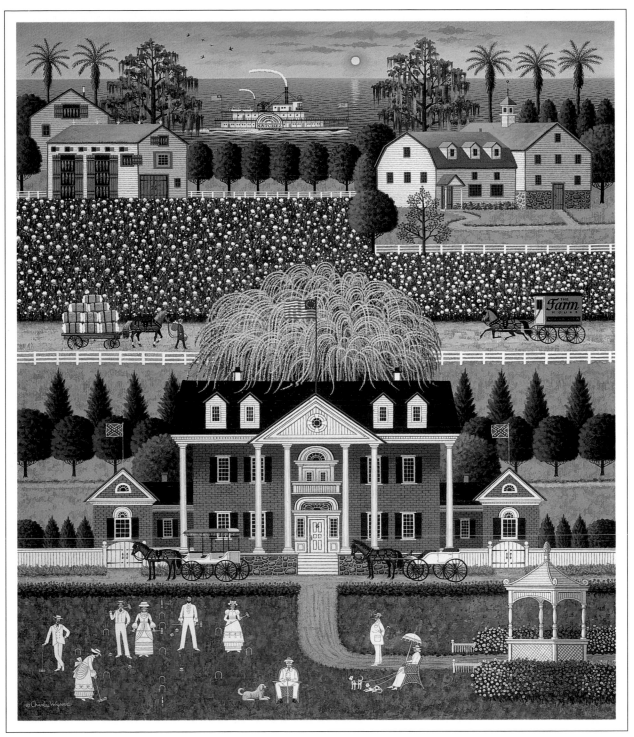

Cotton Country

Cheery Toasts of Love
And Everlasting health
May This coming Year
Be Generous with A
Special kind of Wealth

W

E

Mansfield
Grove
Annual Air
Spectacular

Four Aces
Flying School

74

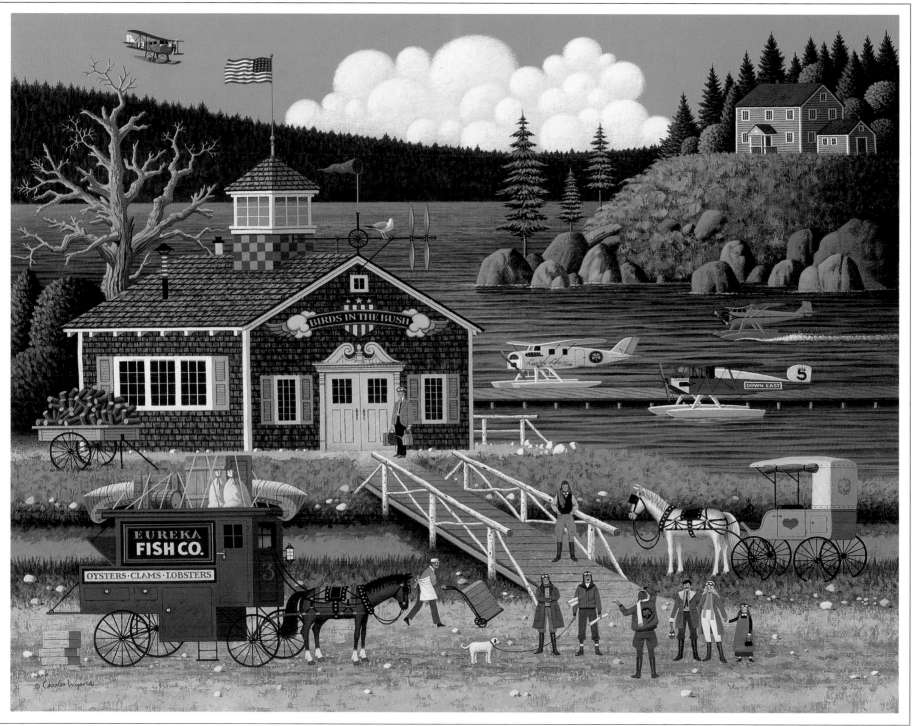

Birds of a Feather

Boston And Beans

MY LOVE AFFAIR WITH HISTORIC BOSTON HAS GONE ON FOR MANY SWEET YEARS, AND TO ARTISTICALLY PORTRAY A GLIMPSE OF THIS GRAND OLD CITY HAS LONG BEEN A DESIRE OF MINE. THE PLANNING STAGES CONSUMED OVER TWO YEARS. FINALLY, AROUSED BY THE CURIOUS COMBINATION OF INTELLECTUAL SOPHISTICATION AND A HOMELY FOOD LIKE BEANS (AS IN JOVIAL REFERENCES TO BOSTON AS "BEAN-TOWN"), I GOT THE IDEA FOR WHAT TURNED OUT TO BE A RATHER MONUMENTAL WORK. MY ORIGINAL AIM WAS TO SHOW A FEW TOWNSPEOPLE, BUT THE CONCEPT KEPT CALLING FOR MORE AND MORE PEOPLE TO PLAY VARIOUS PARTS. THIS PAINTING MARKS THE BEGINNING OF MY FOCUS ON INDIVIDUALS AND DRAMATIC INCIDENTS.

BosTonians And Beans

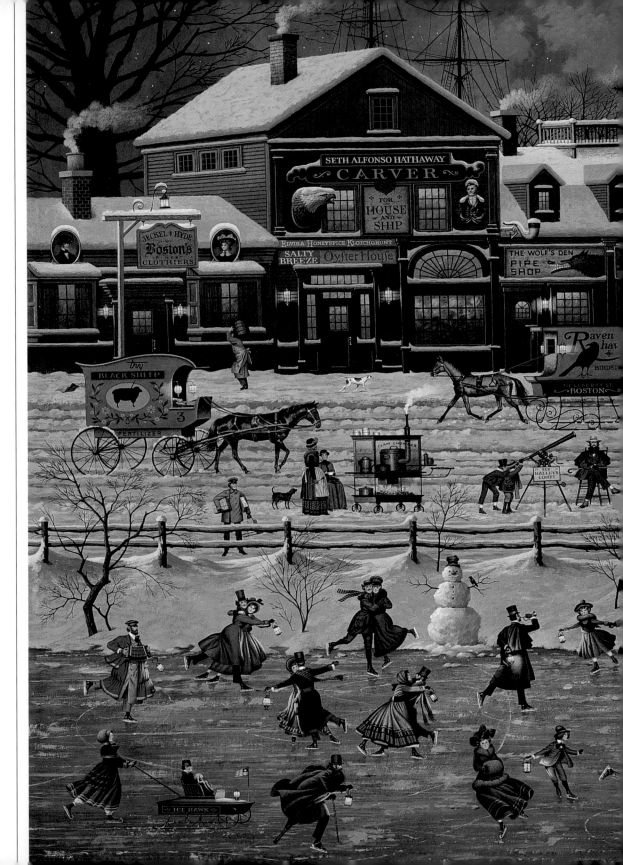

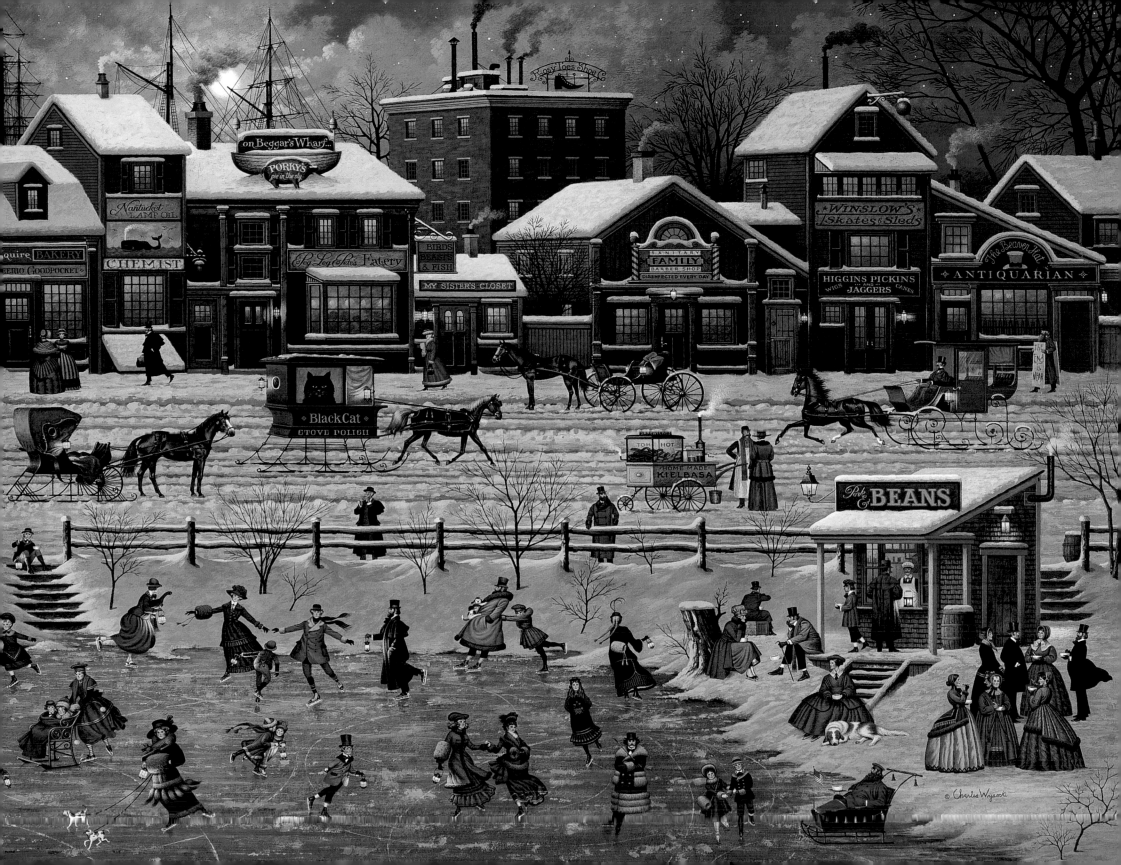

THE WORTH of WORK

MY KEY TO A HAPPY LIFE IS TO LOVE YOUR WORK. THERE ARE MANY, MANY 9-TO-5'ERS, CLOCK-WATCHERS WHO CAN HARDLY WAIT FOR THE WEEKENDS. I FEEL VERY FORTUNATE TO BE BLESSED WITH A SKILL THAT MAKES ME ANXIOUS, WHEN I WAKE UP, TO GET INTO MY STUDIO TO FEEL THE JOY OF CREATING. WHEN I LOOK IN THE MIRROR, SHAVING MYSELF, I SAY, "THE BIG GUY UPSTAIRS HAS GIVEN YOU ANOTHER DAY OF FUN AND GAMES— SQUEEZE IT ALL OUT AND GIVE THANKS THAT LIFE IS SO SWEET."

I WAS AT THE HEIGHT OF A COMMERCIAL ART CAREER WHEN I BROKE AWAY TO DO WHAT MY HEART WAS BEGGING ME TO DO. IT WAS NOT A PIECE OF CAKE TRYING TO SUPPORT MYSELF AS A PAINTER, BUT THE WORD "CAN'T" IS NOT IN MY VOCABULARY. I WAS DETERMINED, AND AMERICA IS A LAND OF OPPORTUNITY.

PERHAPS THAT IS WHY I AM ESPECIALLY ATTRACTED TO WHAT I CALL AMERICA'S "OBSCURE ENTREPRENEURS"— MEN AND WOMEN BUSILY OCCUPIED DOING WORK THEY ENJOY AND MAKING

Jeckel & Hyde
Boston's Finest Clothiers

The Gladhatter
Ebeneezer Crabneck Klotz

JAMES RUSSELL GOLDSMITHS

THE HEAVY PLOW BRINGS WET THY BROW

FORGE

The Fog Bank Cafe

Mr. Swallobark

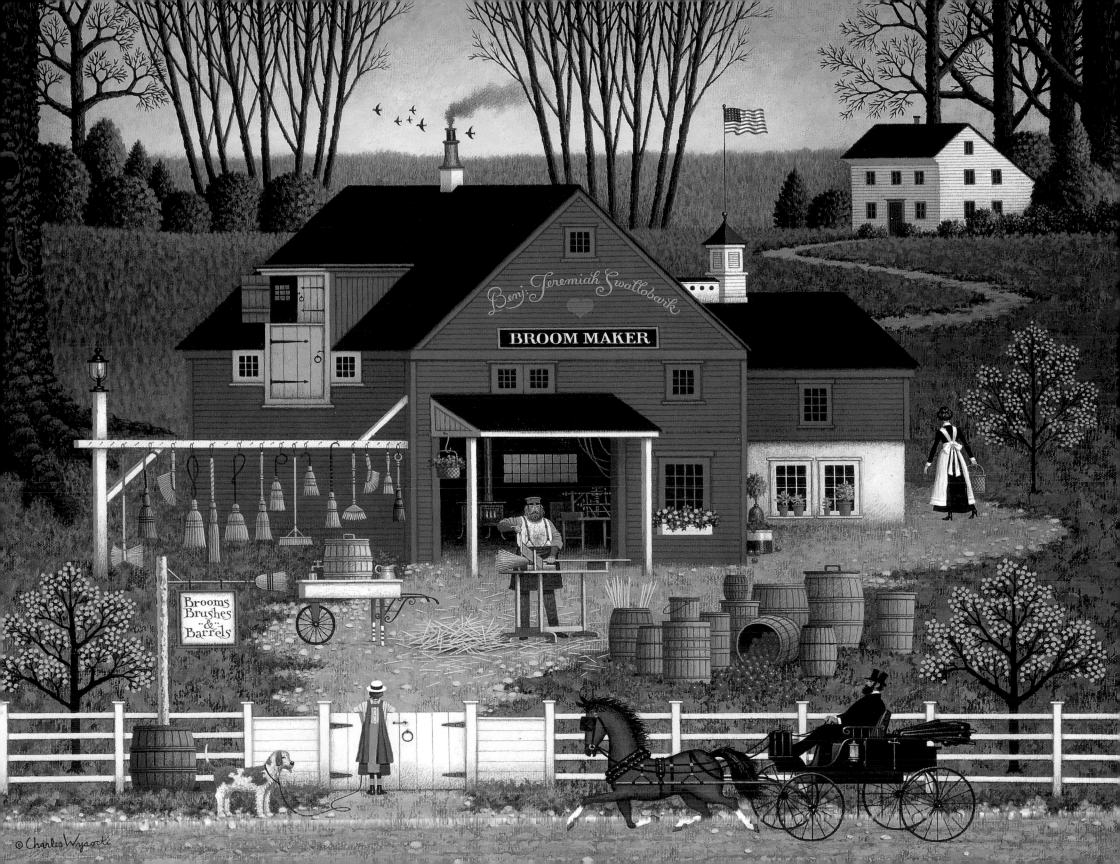

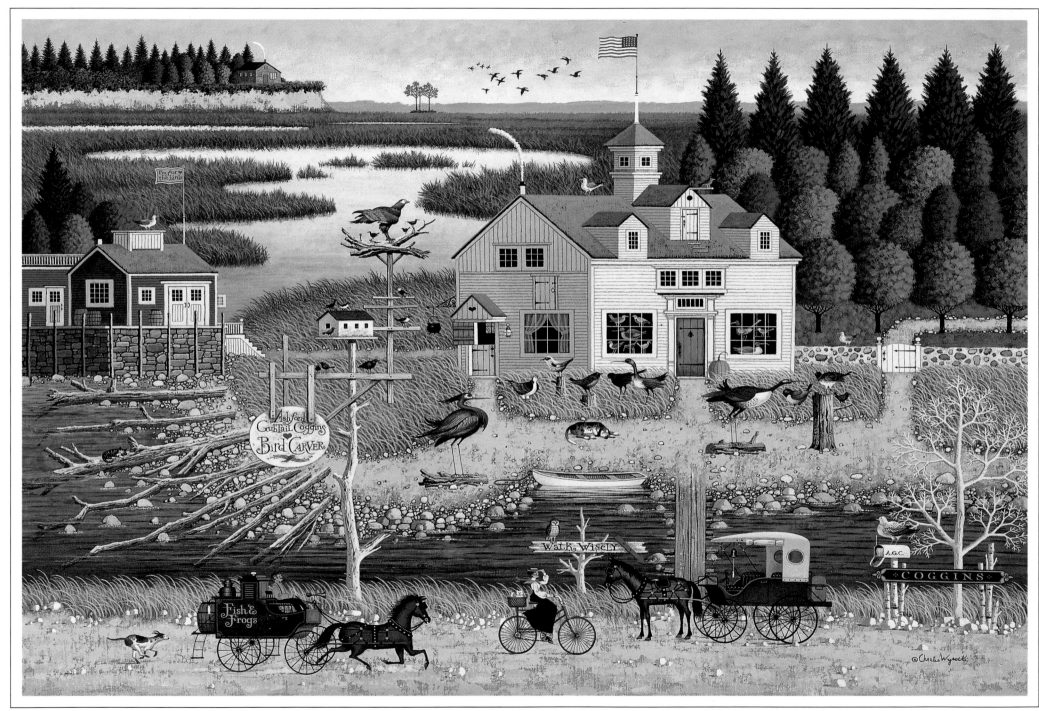

CARVer Coggins

A LIVING FROM IT. FROM OLD BOOKS
AND ON MY TRAVELS ACROSS COUNTRY,
I "COLLECT" OBSCURE ENTREPRENEURS.
MANY OF THEM SHOW UP IN MY PAINTINGS.
SOMETIMES AN OBSCURE ENTREPRE-
NEUR TAKES OVER A WHOLE PAINTING.
"CARVER COGGINS," FOR EXAMPLE, WAS
INSPIRED BY PETER PELTZ, A BIRD
CARVER ON CAPE COD. WE VISIT HIS SHOP
ALMOST EVERY YEAR, AND I'M LUCKY
ENOUGH TO OWN THIRTY OF HIS BIRD
CARVINGS. FROM EXPERIENCE, I KNOW
THAT CREATING REAL ART IS TOUGH
WORK, MENTALLY AND PHYSICALLY.

SeTh Alfonso Hathaway
CARver
I'm for the Birds

The Stool Pigeon Gossip Shop

Hummingbird Sweet Shop

Benjamin PhiNeas Frye
MakeR of Fine Musical
InstRuMents

Rooms To Ferment
by
Pithia BloodLust
WrinkLedeath

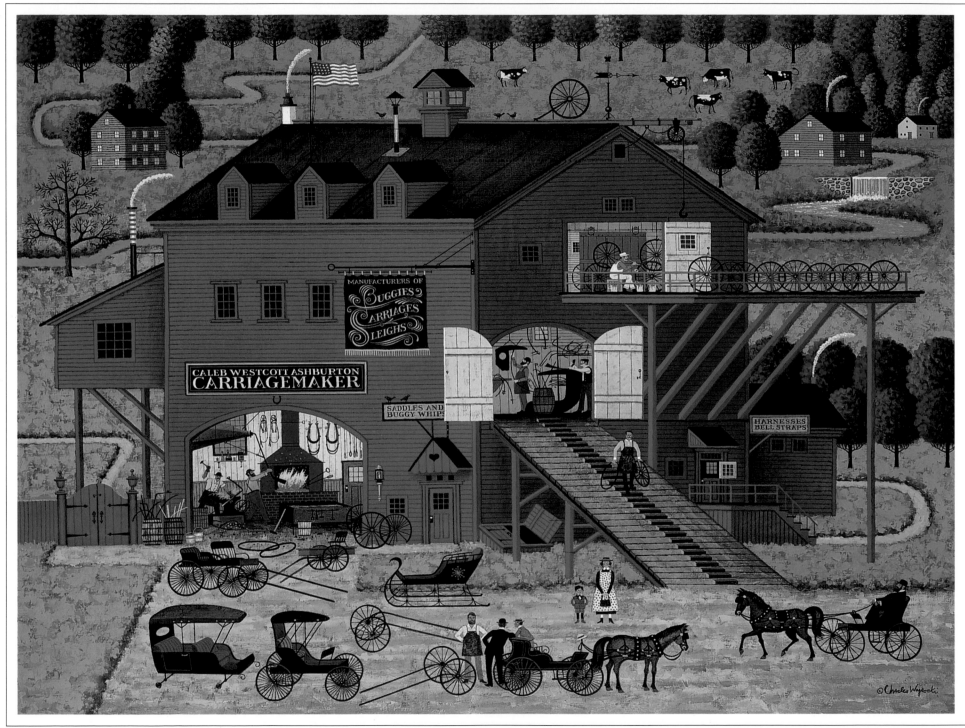

Caleb's Buggy Barn

THE DIGNITY OF HARD WORK HAS ITS RICH, FRUITFUL, SPIRITUAL REWARDS. I WENT TO A DEMANDING TECHNICAL HIGH SCHOOL (CASS TECH IN DETROIT), THEN TO THE ART CENTER SCHOOL OF DESIGN IN LOS ANGELES WHERE I LEARNED ALL THE BASICS. I WORKED AS A COMMERCIAL ARTIST FOR YEARS, BUT I RECEIVED MOST OF MY TRAINING AS A SERIOUS PAINTER IN MY OWN STUDIO, UNDER MY OWN PLODDING DIRECTION. I AM AT MY EASEL BY NINE A.M. AND WORK UNTIL FIVE P.M., SIX DAYS A WEEK AND SOMETIMES SEVEN. I HAVE TRAVELED WHAT SEEMS LIKE THOUSANDS OF BRUSH MILES, BUT I STILL FEEL I HAVE MUCH TO LEARN.

CaLeb Westcott Ashburton, CarriageMaker

Silas Noah Bulfinch
Frog Hollow
Small Boat Shop
"From The
Earth To The Sea"

Dahlia Dinalhaven Makes A Dory Deal

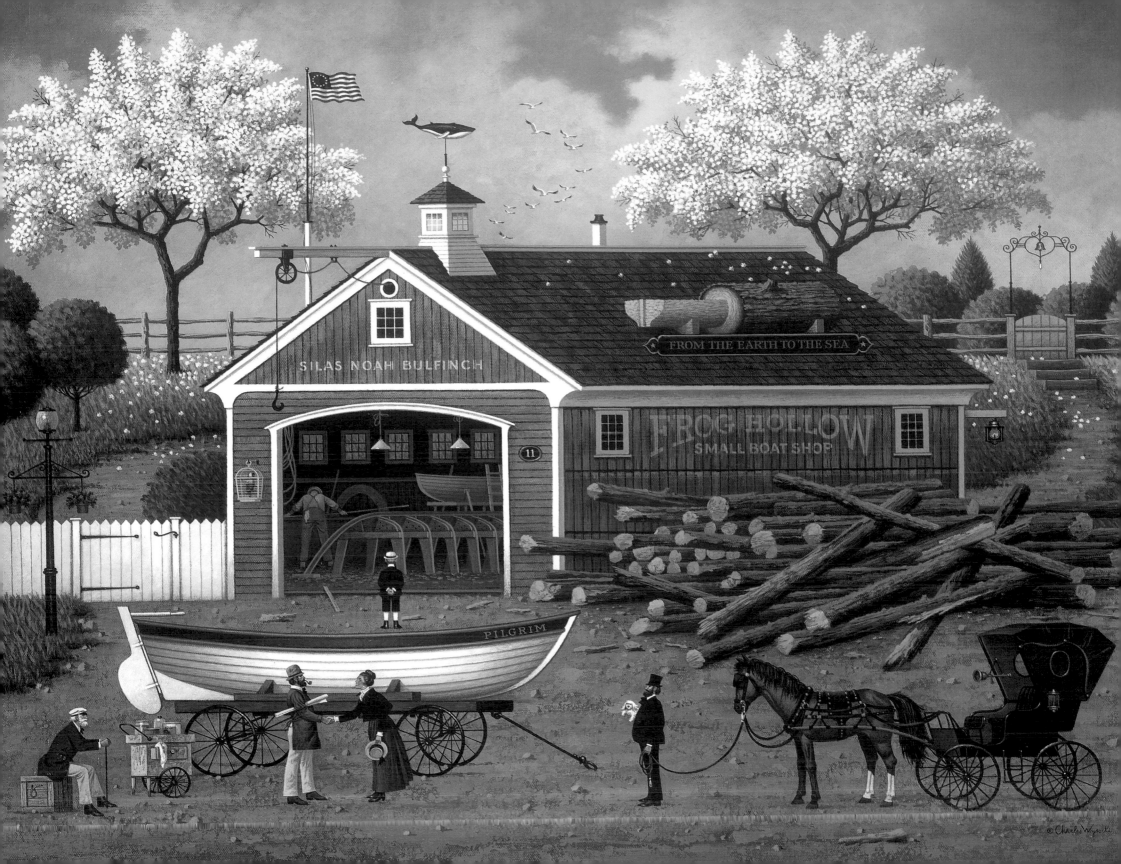

Think THiNK ThiNK

TOO OFTEN, YOUNG ARTISTS PAINT
BEFORE THEY THINK. OVER THE YEARS,
I HAVE DISCIPLINED MYSELF TO THINK
BEFORE I PAINT. WHEN I SEE A
PAINTABLE SUBJECT OR INTERESTING
SITUATION, I PAINT MORE THAN I SEE.
I PAINT WHAT IS TO BE SEEN. I PAINT
WHAT IS INSIDE ME. I PERSONALIZE
THE SCENE, MAKE IT MY OWN SO
THAT THROUGH MY PAINTING, YOU AND
I, VIEWER AND ARTIST, CAN COMMUNICATE.
MY GOAL IS TO CREATE PAINTINGS THAT
ARE A VOICE, NOT AN ECHO.

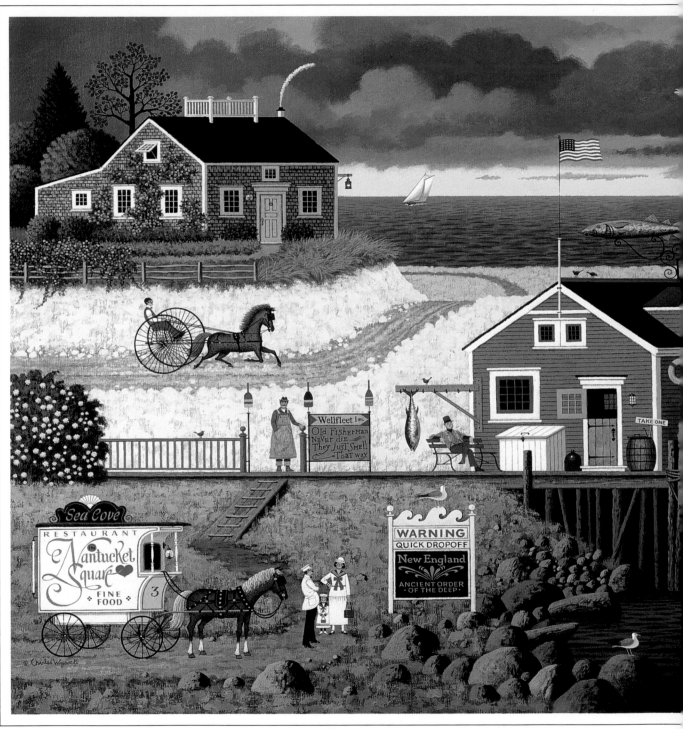

DeVilbELLy Bay

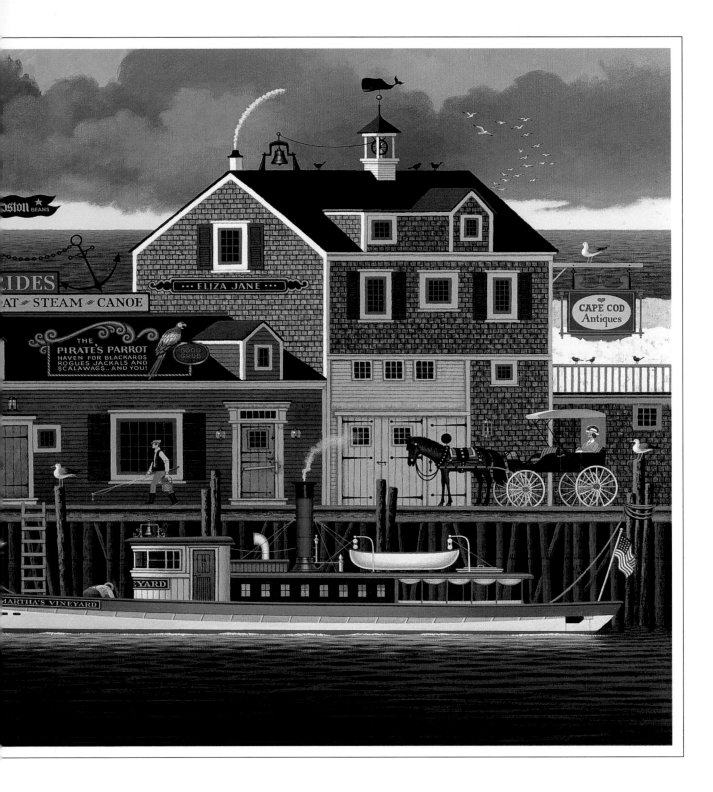

Uncle Waldo's Fish Market

The PIRATE'S PARROT HAVEN FOR BLACKARDS, ROGUES, JACKALS and ScaLaWAGS...aND YOU

A R T
STORE

The Whistling Oyster
Fine Food

America

Stanley Casimir Pulaski
Groceries

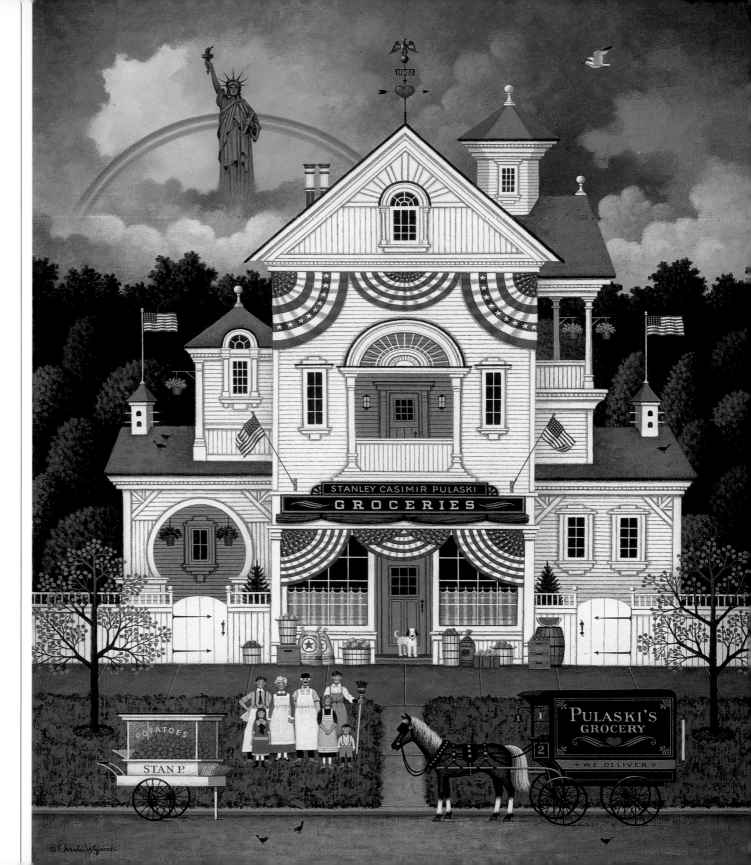

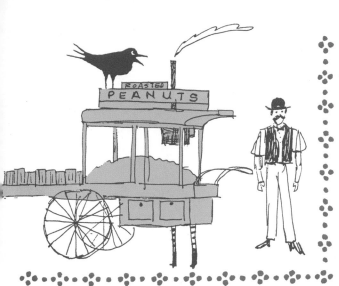

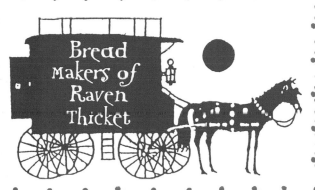

Bread Makers of Raven Thicket

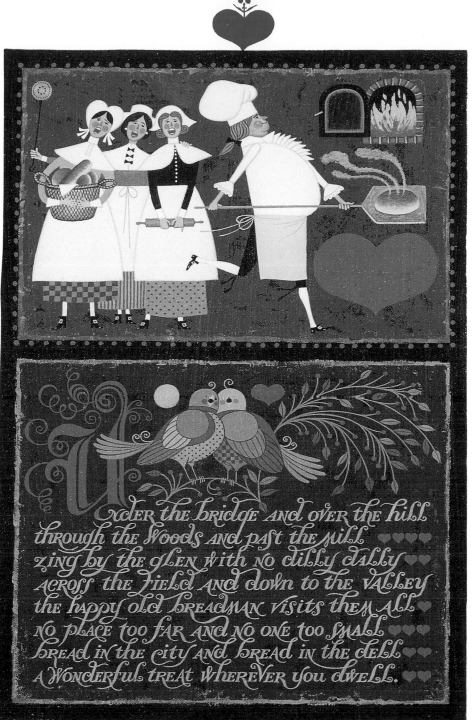

Under the bridge and over the hill
through the woods and past the mill
zing by the glen with no dilly dally
across the field and down to the valley
the happy old breadman visits them all
no place too far and no one too small
bread in the city and bread in the dell
a wonderful treat wherever you dwell.

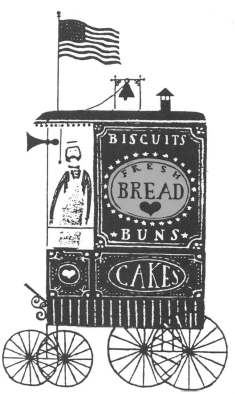

Charlie's Pastries

Lady Liberty's Independence Day
Enterprising Immigrants

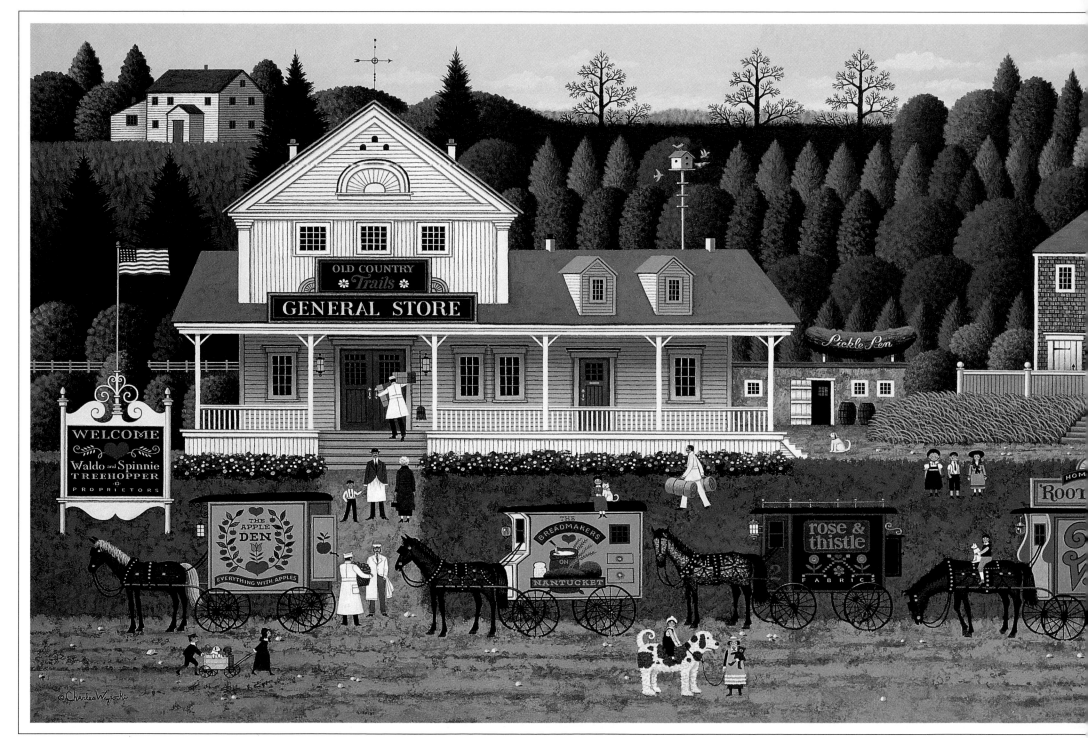

Storin Up

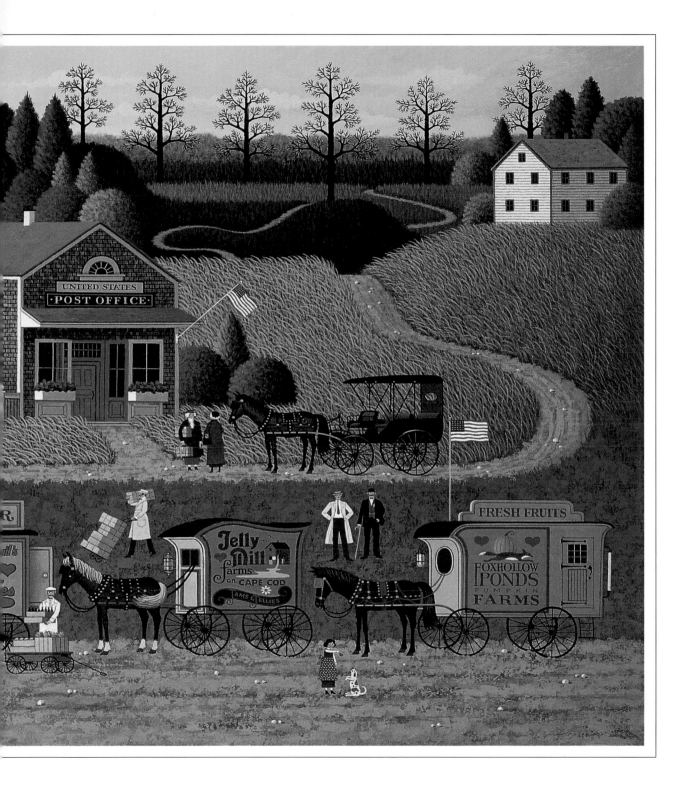

The Cape Inn

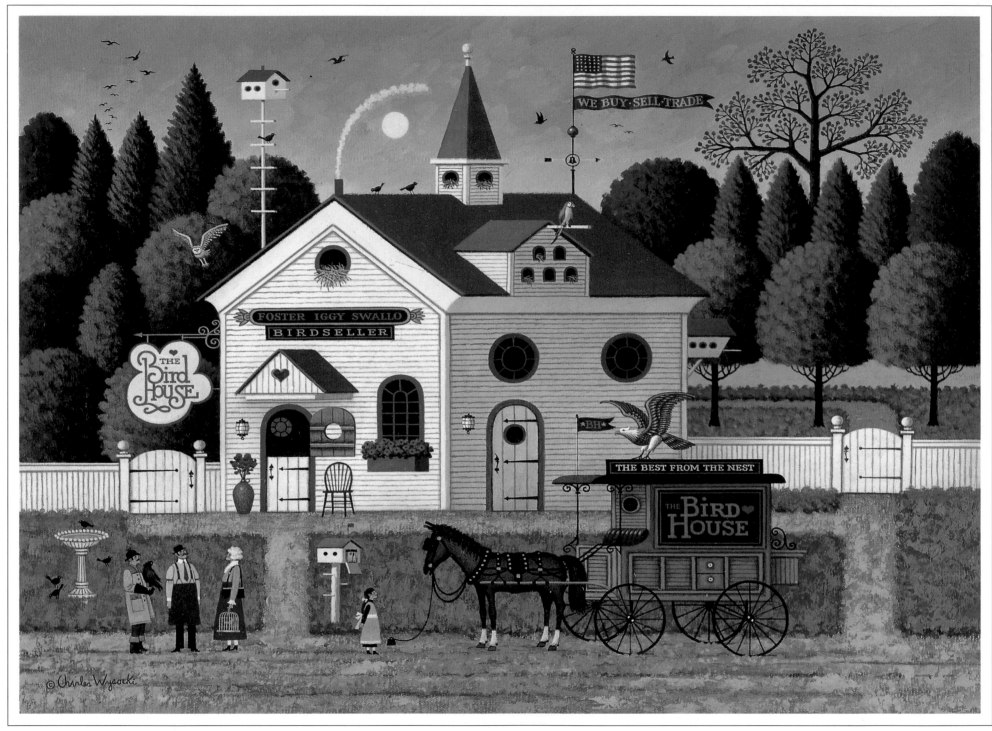

The BirdHouse

I START SKETCHING ON SMALL PIECES OF TISSUE PAPER AND TACK THEM UP ALL OVER THE CANVAS—IT MIGHT BE THREE OR FOUR TISSUES DEEP. THEN AFTER A WHILE, I'VE GOT THIS MOUNTAIN OF TISSUE PAPER. I MOVE THINGS AROUND UNTIL I'VE GOT WHAT I FEEL IS THE RIGHT ORDER.

THEN I LAY ONE TISSUE OVER THE WHOLE THING AND I DO THE MASTER DRAWING OF WHAT'S UNDERNEATH. IT'S A BATTLEGROUND TO ENSURE THAT EVERYTHING FITS JUST RIGHT. WHEN THE PAINTING IS FINISHED, YOU CAN'T DISTURB ANYTHING WITHOUT DISTURBING THE WHOLE PAINTING.

Uncle Chuckie's Bird Farm

The Best From The Nest-The Birdhouse
Foster Iggy Swallo, Birdseller
"I'M for the Birds"

93

Little Ann's Ginger Snaps

The Overflow Antiques

Posie's
Beauty
Parlor

"I Turn
Hayheads
into
Cornsilk"

The Best Eats in Town

Lovebirds Inn

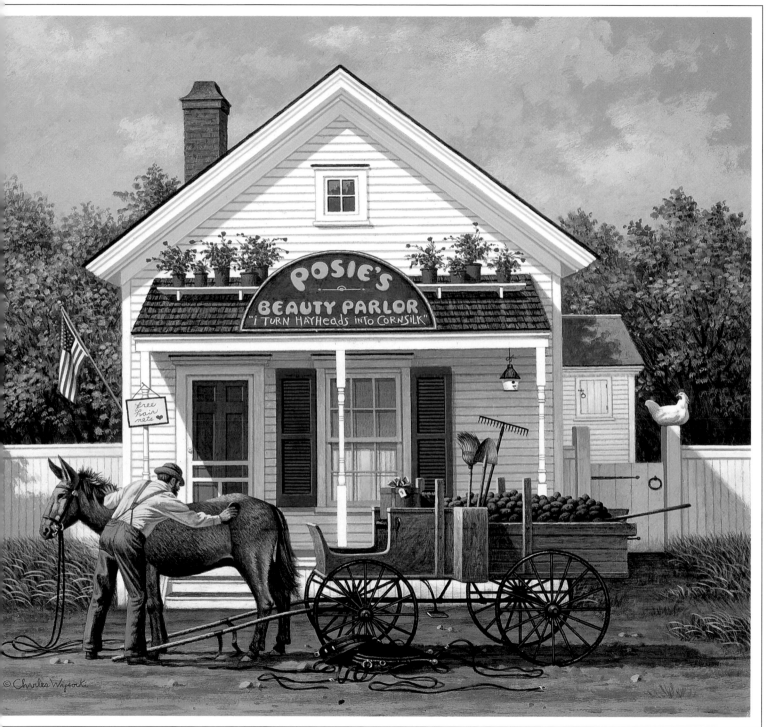

Beauty And The Beast

Sanitary Family
Barber Shop
Disenfected Every Day

Hattie Cheerio
Goodpocket

Elvira Honeyspice
Klotchgrunt

95

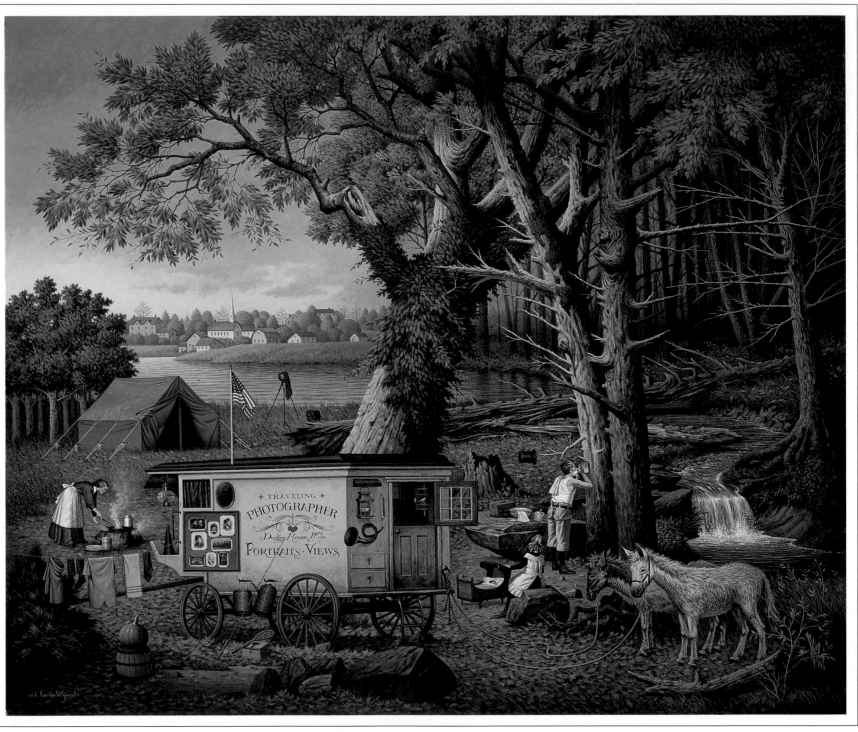

The Memory Maker

Hatch & Co. Makers of Fine Musical Instruments

The Beaver Hat Tavern

Blacksmith & Horsecare

97

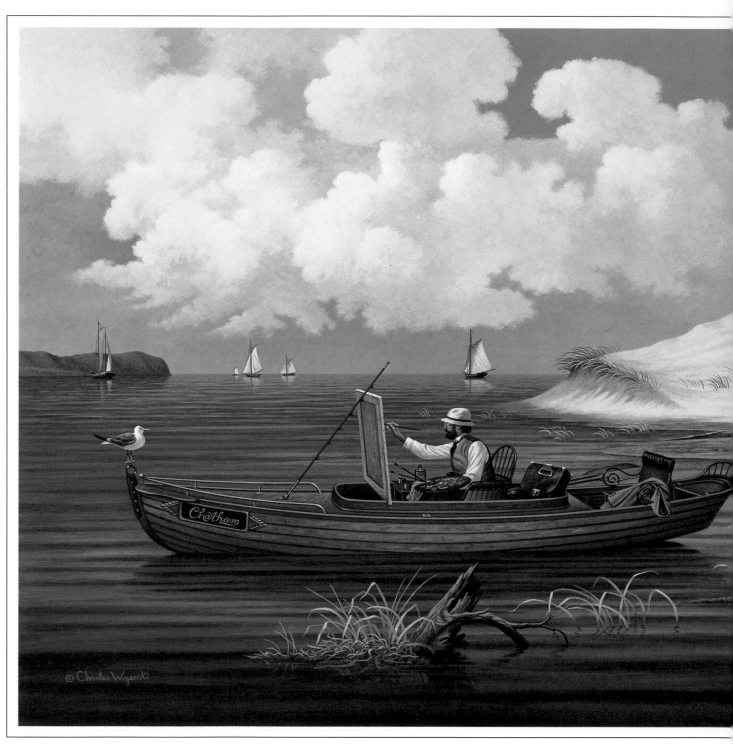

Feathered Critics

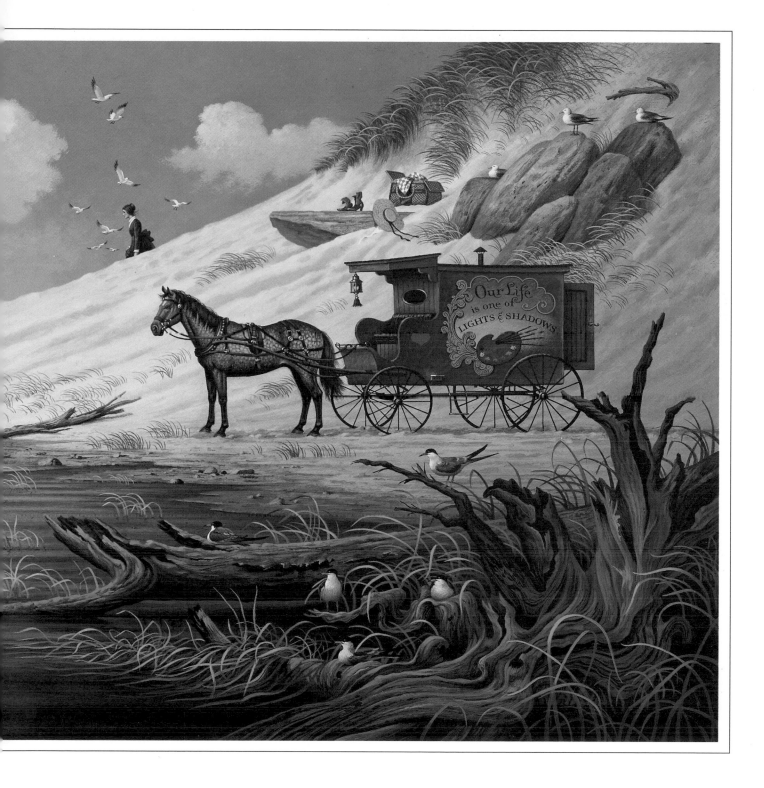

99

THE LURE of THE SEA

The Wharf Rats Club

Capt. Barney's Ship Supplies

Clyde's Live Bait

Hodge's Hodge Podge

THE SURF, THE DUNES, THE GRASSES, THE FISHING BOATS, THE LOBSTER TRAPS AND SHINGLED COTTAGES—EVERYTHING ABOUT THE NEW ENGLAND SEACOAST PROVIDES INSPIRATION FOR ME TO PAINT. SINCE OUR FIRST VISIT SHORTLY AFTER WE WERE MARRIED, LIZ AND I HAVE RETURNED AGAIN AND AGAIN TO MAINE, CAPE COD, MARTHA'S VINEYARD, NANTUCKET ISLAND—MY FAVORITE PLACES, ALL BOUNDED BY THE OCEAN.

WE LIKE TO GO IN THE OFF-SEASON, ESPECIALLY IN AUTUMN WHEN THE CROWDS ARE GONE AND WE CAN SPEND HOURS WALKING THE DESERTED BEACHES, WATCHING THE WAVES AND THE CLOUDS, AND HEARING THE CRY OF THE GULLS. PEOPLE COMPLAIN ABOUT THE SEA WEATHER, THE FOG, THE WIND, BUT I'M CRAZY ABOUT WIND. I LOVE TO HEAR IT ROAR. I'M AT MY CREATIVE BEST WHEN THE WEATHER IS STORMY WITH DARK SKIES, BRIGHT FLASHES OF LIGHTNING, POUNDING THUNDER OR WHEN IT'S SNOWING

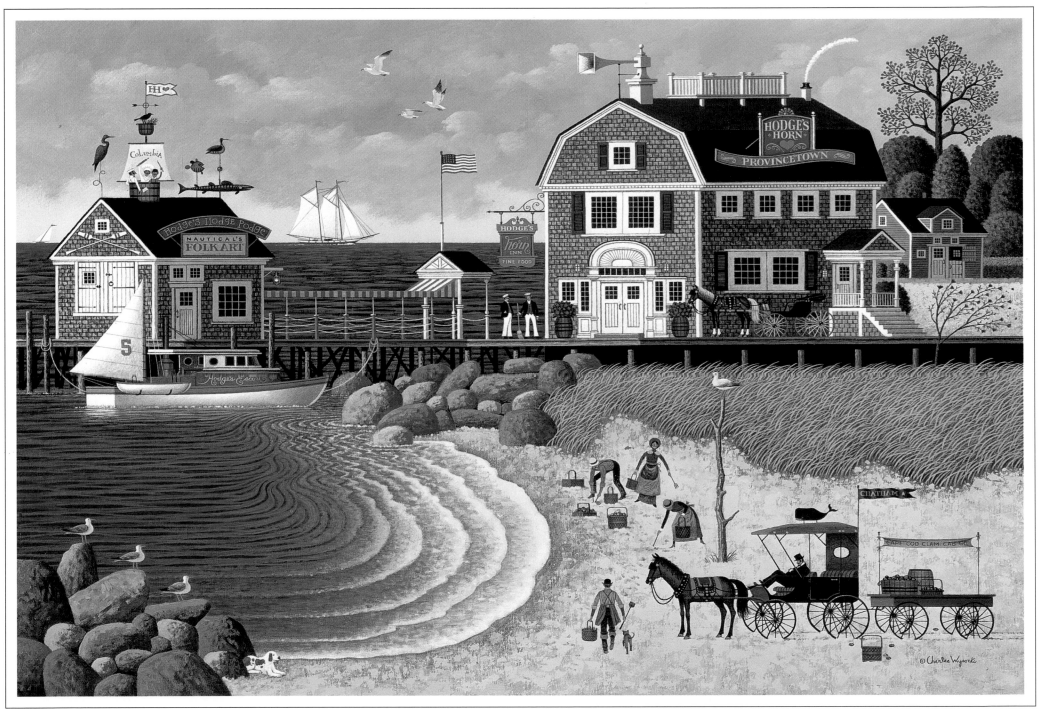

CLAMMERS AT HODGE'S HORN

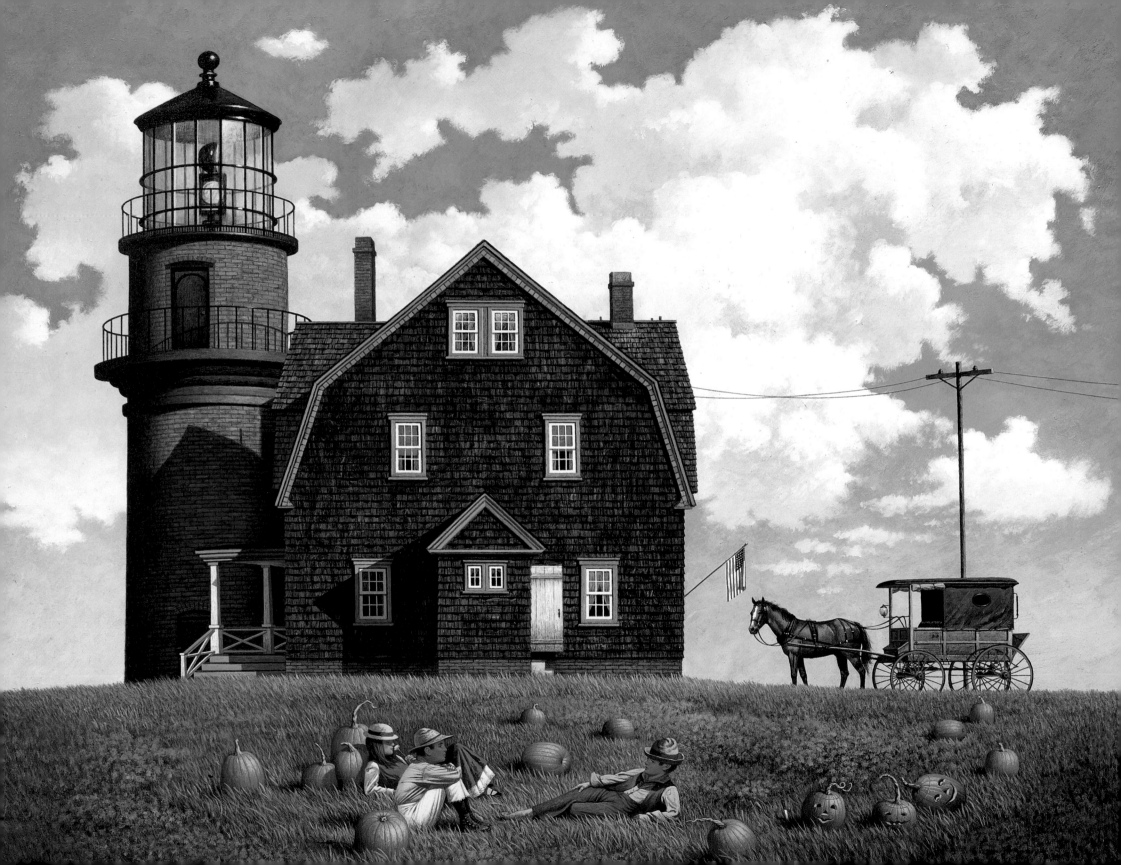

FURIOUSLY. THESE DYNAMICS OF NATURE ENCOURAGE ME TO THINK DEEPER WITHIN MYSELF IN ORDER TO PRODUCE PAINTINGS THAT PROJECT WHAT I TERM "SILENT POETRY." MAYBE AT THESE ADVENTUROUS TIMES I'M FRIGHTENED INTO CREATIVITY FOR FEAR THAT THE

POWERFUL FORCES OF MOTHER NATURE WILL DO AWAY WITH ME, AND I'VE GOT TO FINISH THAT MASTERPIECE QUICK!

I LIKE TO TELL LITTLE STORIES IN MY PAINTINGS, AND ALONG THE NEW ENGLAND SEACOAST I SEE STORIES EVERYWHERE—IN WHALING MUSEUMS,

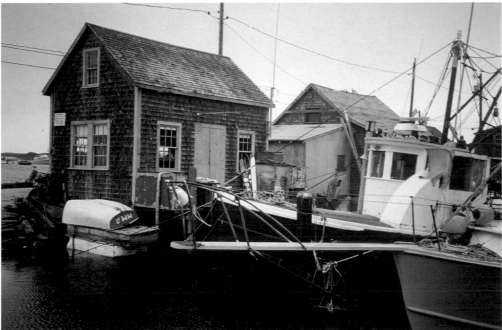

Gay Head Light

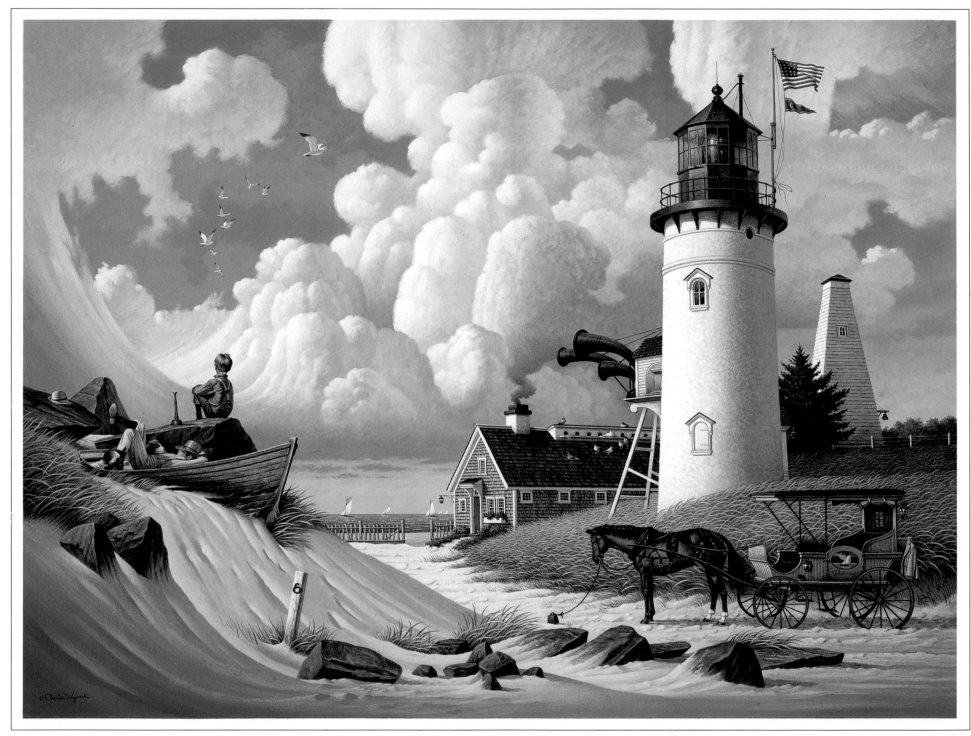

Dreamers

I wish each flowing sail
Would bring you Happy waves,
Good weather and white clouds
And sunny, Sunny days.

BIRds, Beasts & Fish

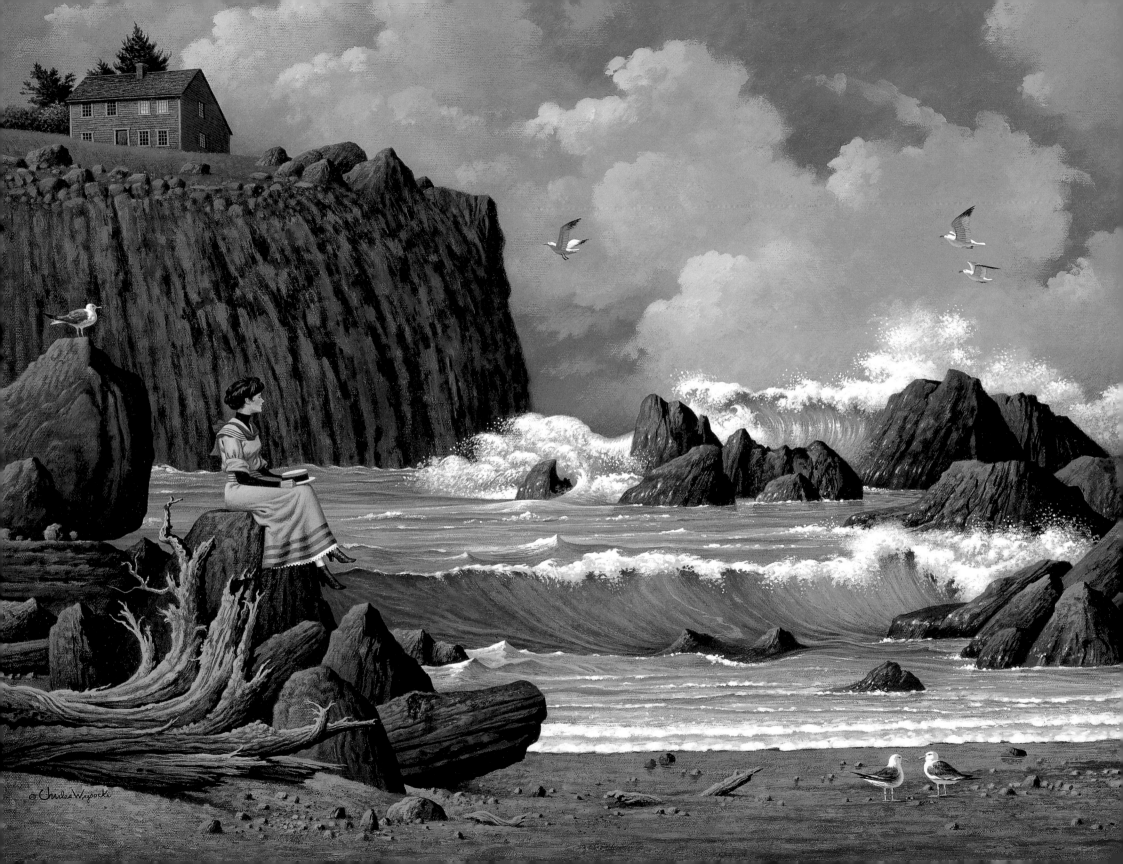

CAPTAINS' HOUSES, ANTIQUE BOOKS AND RECORDS. I DON'T PAINT WHAT I READ, BUT WHAT I READ INSPIRES ME TO CREATE MY OWN SCENES AND STORIES. FOR EXAMPLE, ALTHOUGH I'M A MEMBER OF THE UNITED STATES LIGHTHOUSE SOCIETY AND HAVE COLLECTED DOZENS OF PHOTOGRAPHS OF REAL LIGHTHOUSES, I CREATED A LIGHTHOUSE OF MY OWN DESIGN FOR THE PAINTING "DADDY'S COMING HOME." THE KEEPER'S HOUSE, TOO, IS MY OWN INVENTION, A HOUSE I'D LIKE TO LIVE IN—AND HOPE THE KEEPER DOES, TOO. I EVEN CREATED A LOGBOOK FOR AN IMAGINARY WHALING SHIP CAPTAIN.

From here to there are Long, Long ways
Measured by Miles, nights and days
Thoughts of you bring you near
With hopes you'LL come home this year

You've Been So Long at Sea, Horatio

Wednesday Night Checkers

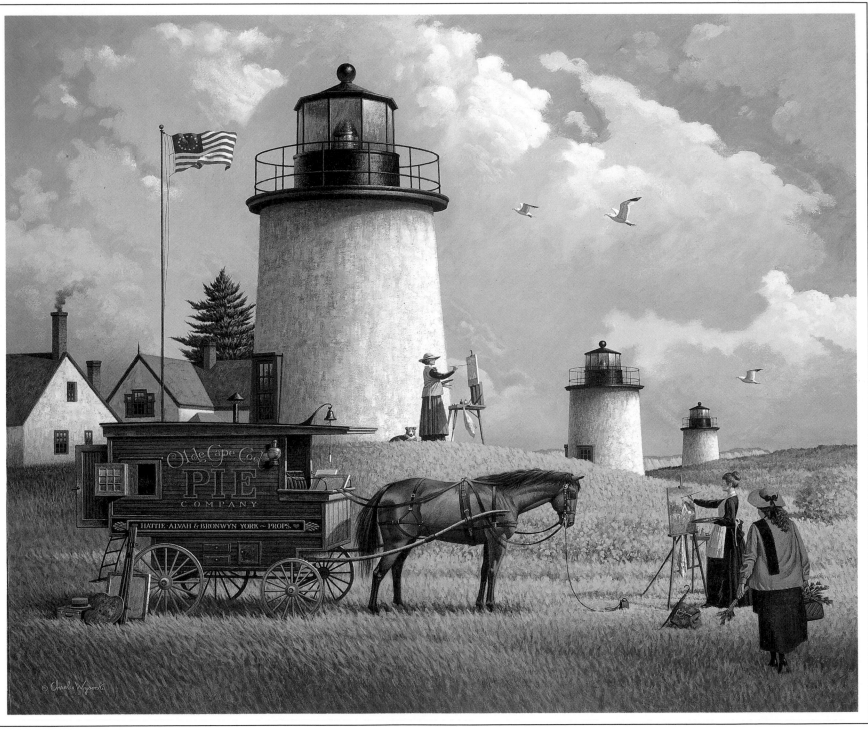

The Three Sisters of Nauset—1880

Captain's Log 1861

Sept. 11 - Seas are calm, dolphins are jumping.
 Hoping tomorrow for a humpback or something.

Sept. 12 - Water choppy—we sighted a fin;
 She flipped away with her next of kin.

Sept. 13 - Met a whale off Nantucket
 Threw out a harpoon and stuck it.
 Broke her Lines and ran to sea
 Whistling and wounded but happy and free.

1620

Fairhaven
By the Sea

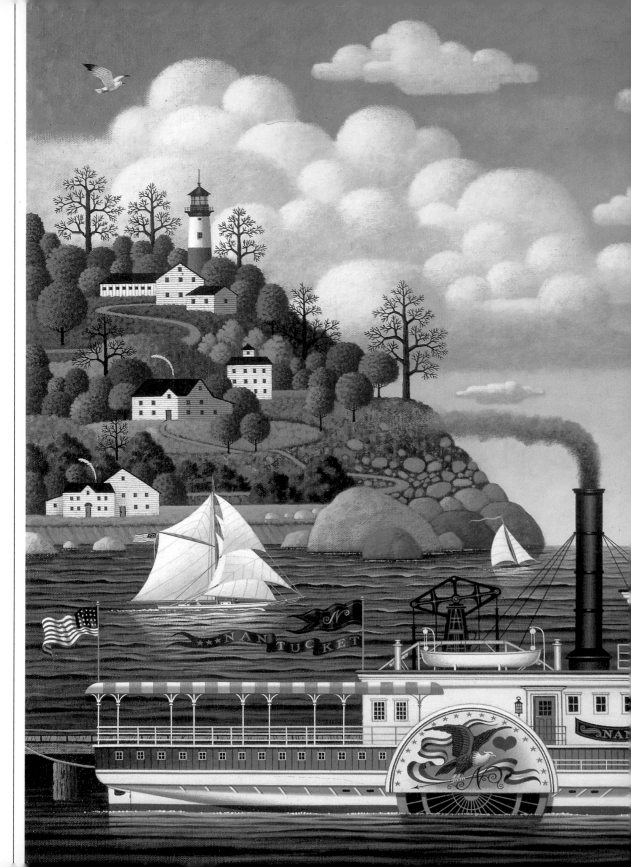

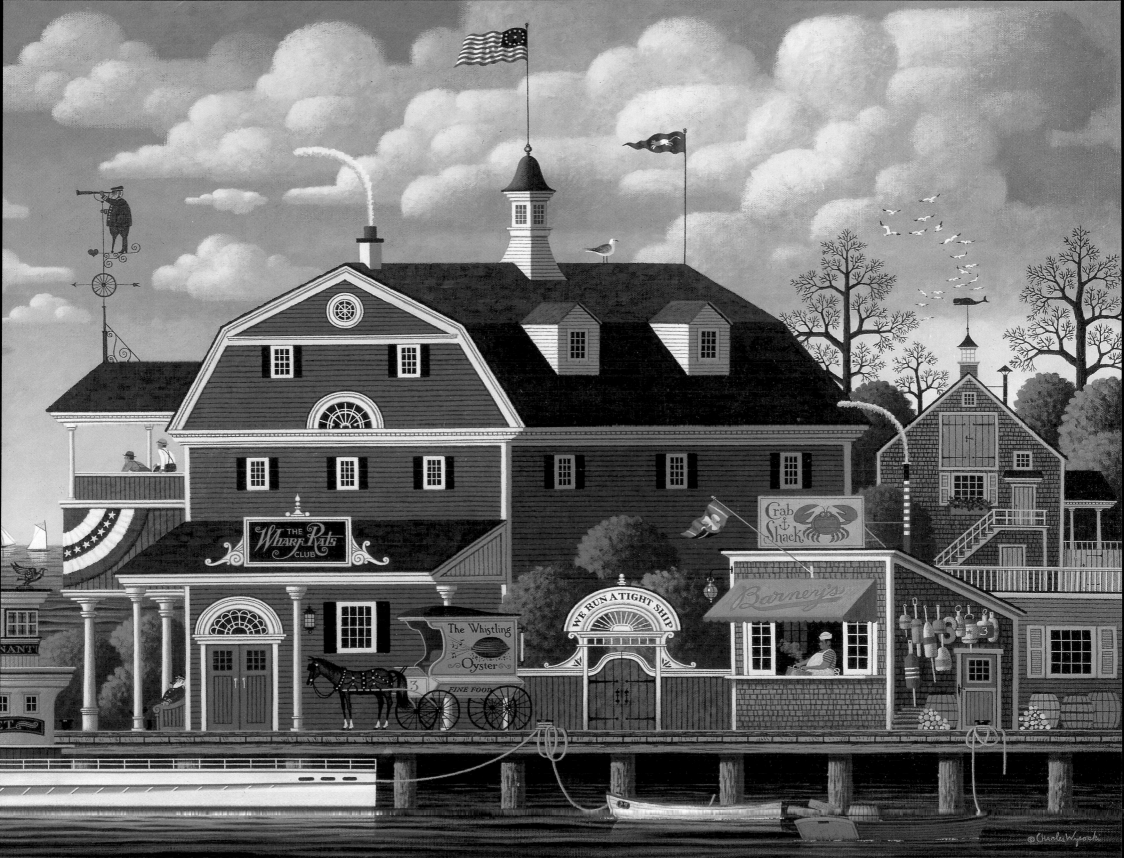

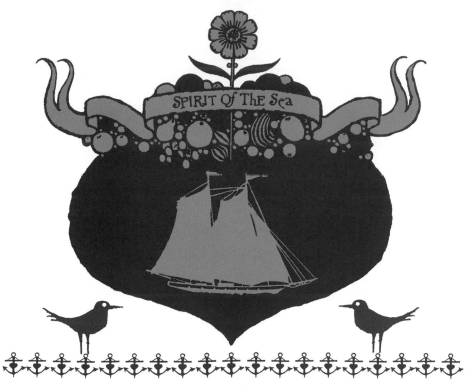

SPIRIT OF THE SEA

My sailing treasure is home from the sea
My Valentine is here, kissing me
My beloved Captain
Out of my heart and into my arms

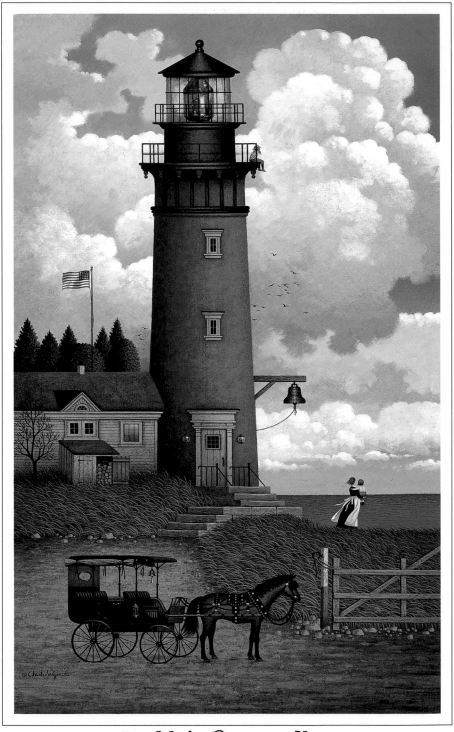

Daddy's Coming Home

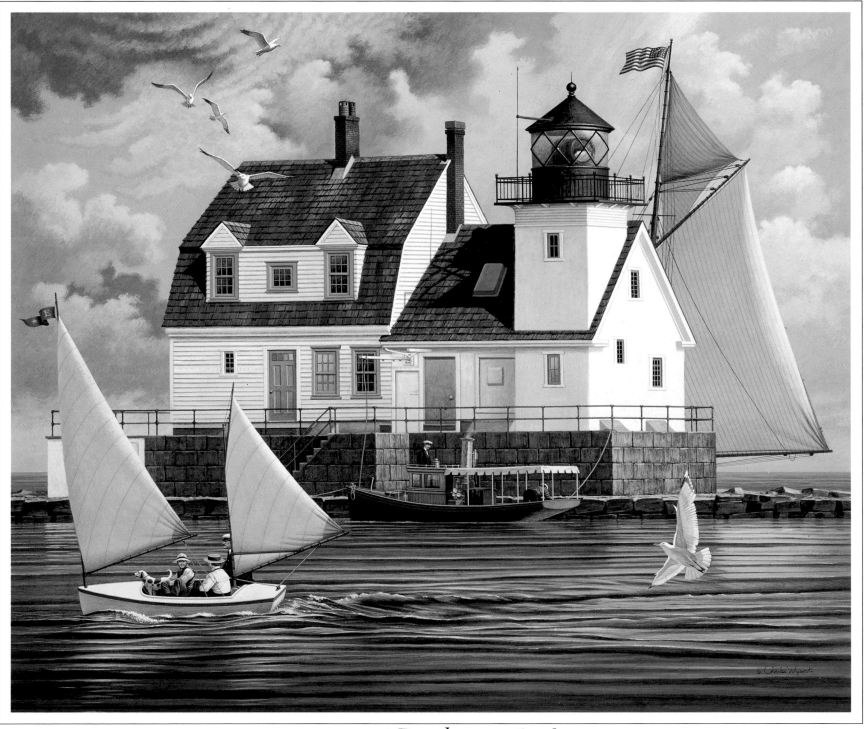

Rockland Breakwater Light

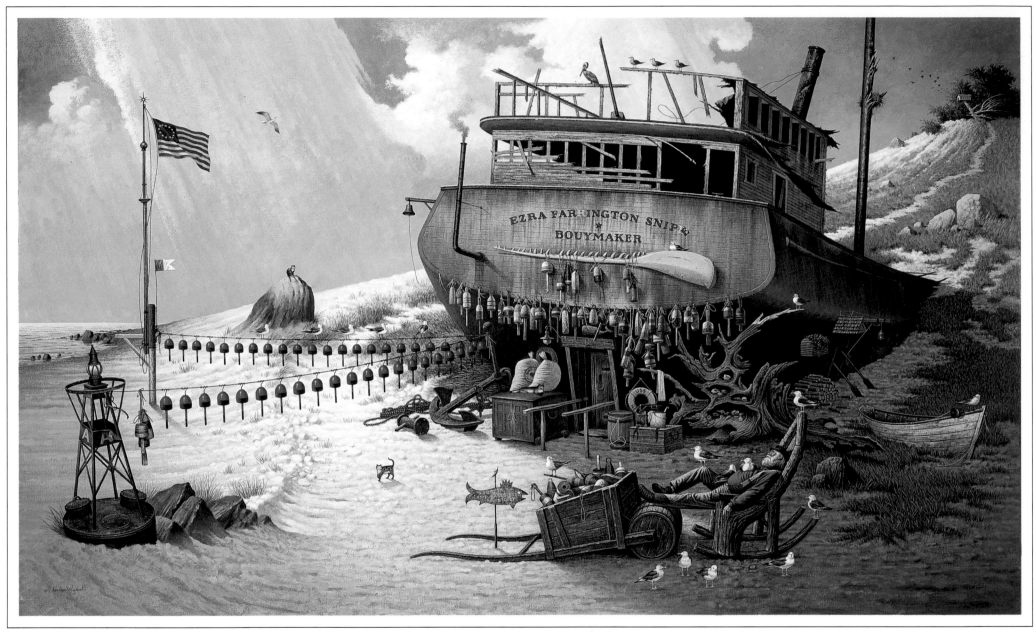

Where the Buoys Are

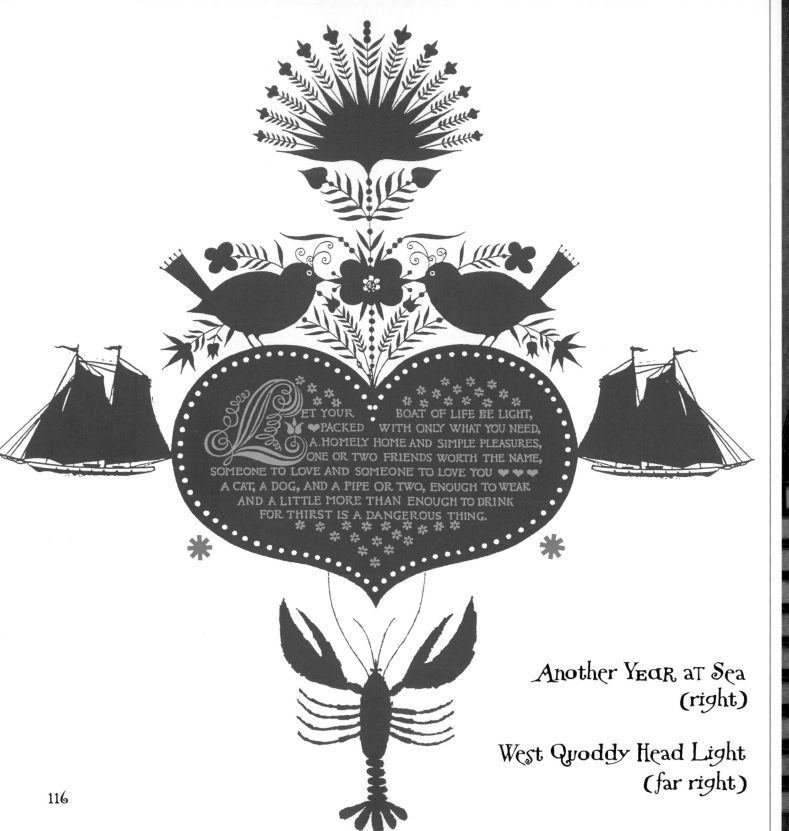

LET YOUR BOAT OF LIFE BE LIGHT,
PACKED WITH ONLY WHAT YOU NEED,
A HOMELY HOME AND SIMPLE PLEASURES,
ONE OR TWO FRIENDS WORTH THE NAME,
SOMEONE TO LOVE AND SOMEONE TO LOVE YOU ♥ ♥ ♥
A CAT, A DOG, AND A PIPE OR TWO, ENOUGH TO WEAR
AND A LITTLE MORE THAN ENOUGH TO DRINK
FOR THIRST IS A DANGEROUS THING.

Another Year at Sea
(right)

West Quoddy Head Light
(far right)

116

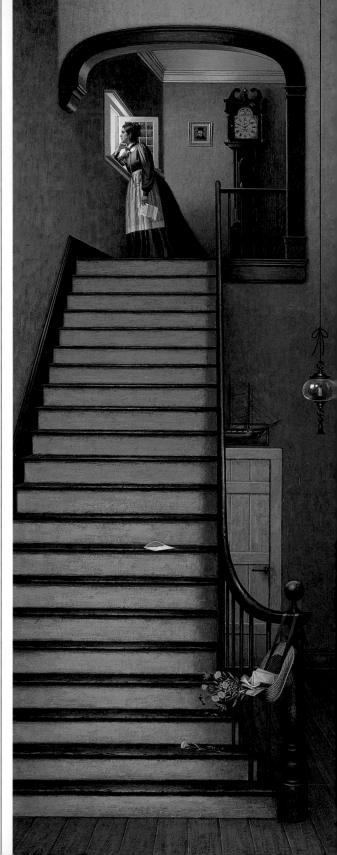

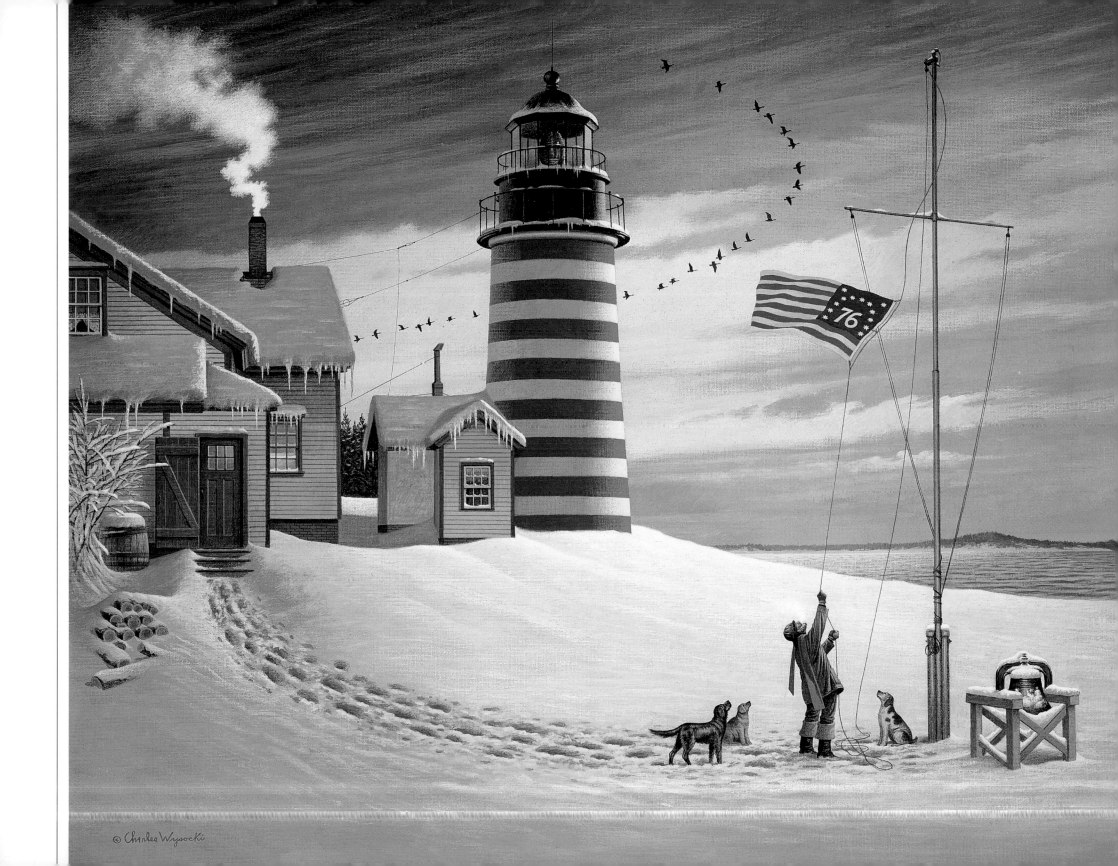

© Charles Wysocki

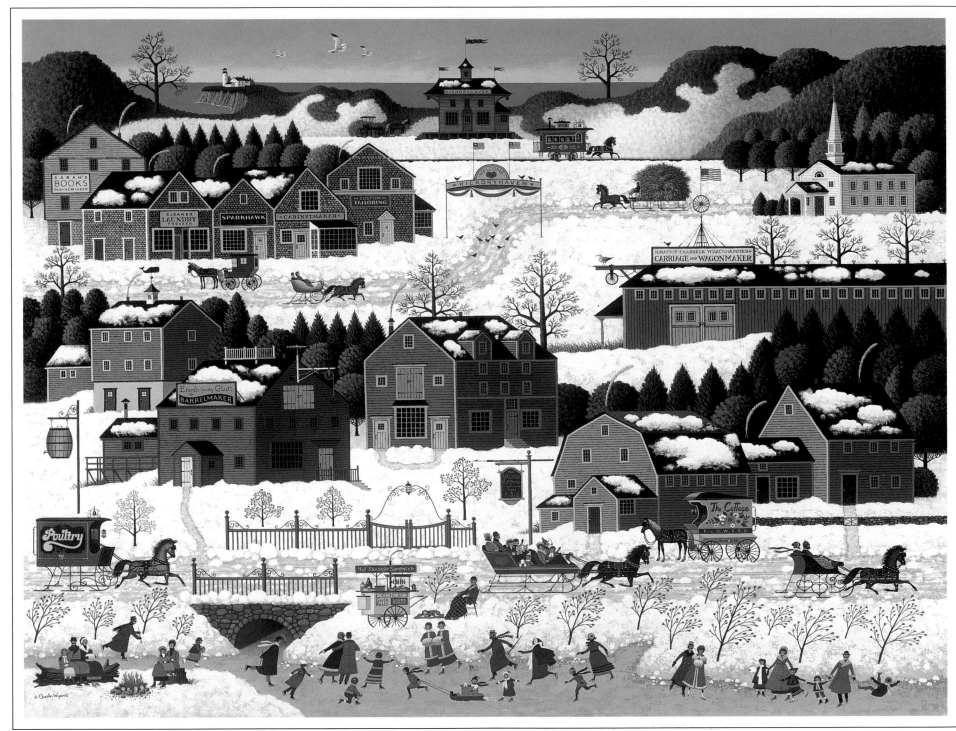

Hickoryhaven Canal

THE White Elephant
NANTUCKET ISLAND
MASSACHUSETTS 02554

10/15/85

A long walk on the beach with only me, the ocean waves, the dark brooding clouds, the cry of the birds, the waving grass and the warm sand under my feet and I was in heaven. Now, I'm inside our cozy room. The weather has turned blustery, the fireplace is crackling and I can hear the gulls wailing in the wind outside my window. It is truly a night for a good book, a mystery? and I will delight in this undertaking at the demise of this letter to myself. — It was truly a delightful day walking through the streets of Nantucket. Everywhere the poetry of people, places and things lit up my heart with inspiration for painting too numerous that I knew I could never complete. This historic place stirred my soul with a special feeling of a way of life, which unfortunately, will never be seen or felt again. I hope I can put on canvas just "some" of the beautiful pictures recorded in my mind that this grey lady has afforded me to experiment with. What a lovely lovely day. Drinking in the feast of this island is a special treat to an artist's innermost "romantic core and a warm inspirational time I will never forget. Please Charles, do "justice" to this fine old island when your brushes come "alive"! — I'll try my damnedest. On to my book.

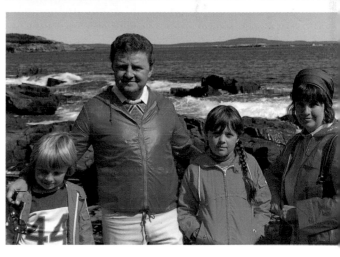

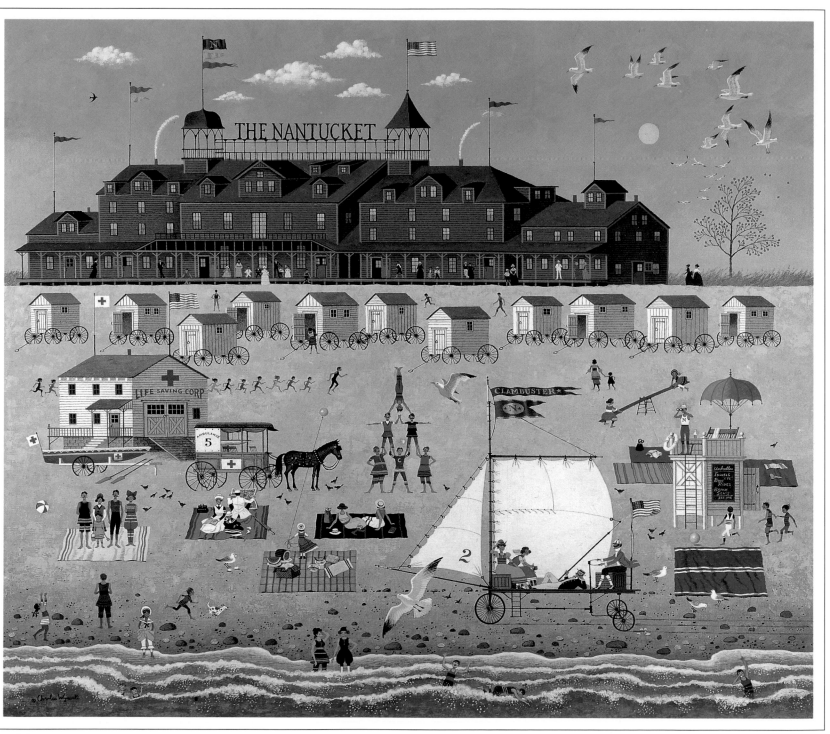

The Nantucket

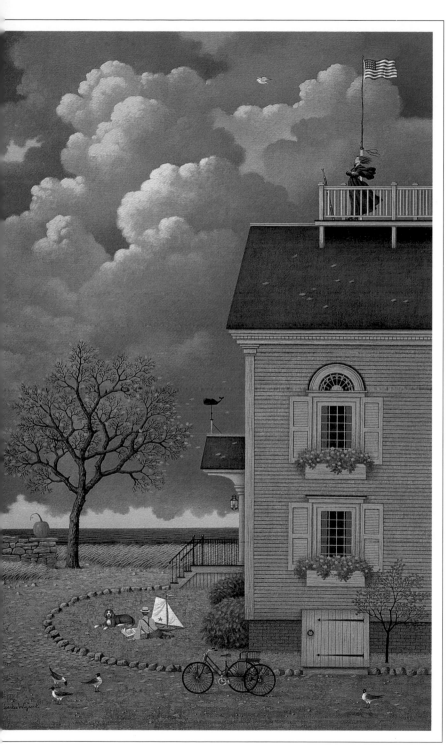

Yearning for My Captain

Capt.
Stephen Clay

"Old Mill
Cargo"

"Sailor's
Limp Inn"

Pickhiggins
CoopersMythe

THE JOY OF LOVE

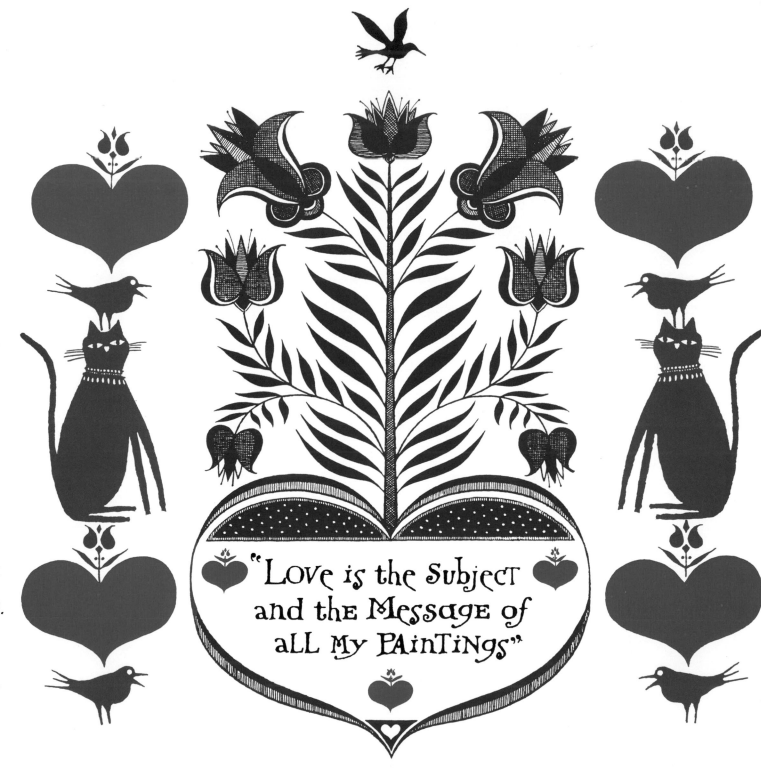

"Love is the Subject and the Message of all My Paintings"

FOR YEARS, ELIZABETH AND I LIVED IN CALIFORNIA AND DREAMED ABOUT MOVING TO NEW ENGLAND. BUT EACH TIME WE VISITED THE NORTHEAST, WE SAW IT AS IF FOR THE FIRST TIME. I WANTED TO KEEP THAT WONDERFUL FRESHNESS—UNDIMMED BY FAMILIARITY, SO WE DECIDED TO CREATE A LITTLE BIT OF NEW ENGLAND ON WOODED PROPERTY WE OWNED IN CALIFORNIA. WE BUILT A COLONIAL HOUSE VERY LIKE MY FAVORITE HOUSE IN NEW ENGLAND, THE ASHLEY HOUSE IN HISTORIC DEERFIELD, MASSACHUSETTS.

IT'S A COZY, DARK, SHELTERING HOUSE, FILLED WITH EARLY AMERICAN FURNITURE AND ANTIQUES WE HAVE COLLECTED OVER THE YEARS. THERE ARE CLOCKS AND CROCKS, CARVINGS, SIGNS, DECOYS—INTERESTING THINGS EVERYWHERE BUT IT'S VERY ORDERLY. EACH OBJECT IS CAREFULLY PLACED TO CONTRIBUTE TO THE OVERALL PATTERN. I THINK OF EACH ROOM AS A PAINTING, AND PATTERNS ARE AN IMPORTANT PART OF MY PAINTING STYLE. MORE RECENTLY, WE BUILT ANOTHER HOUSE, THIS ONE IN THE DESERT, WITH LONG VIEWS OF THE MOUNTAINS AND A

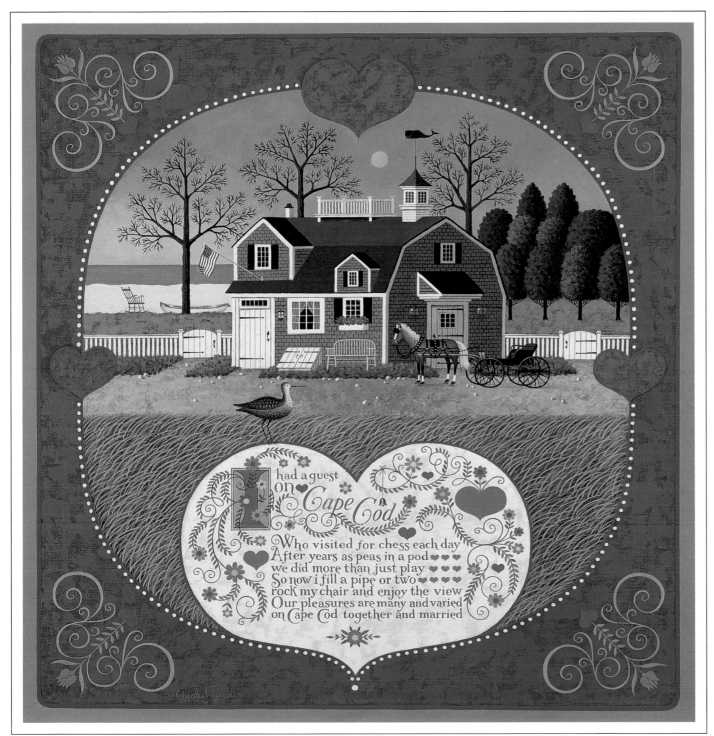

Love is something so divine
Description would but make it less
'Tis what I feel but can't define
'Tis what I know but can't express

Sweet Heart Chessmate

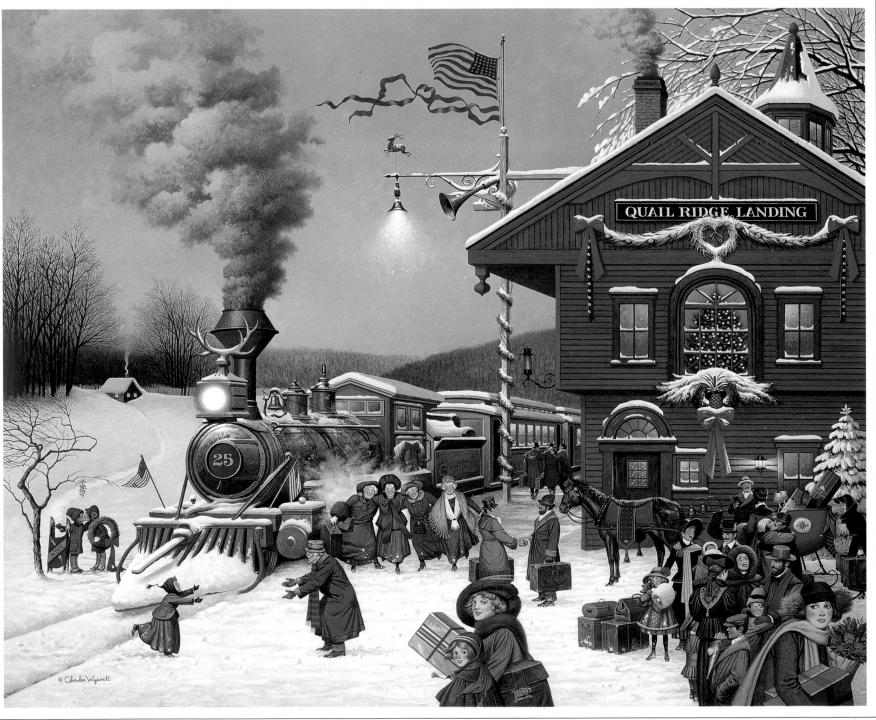

Whistle Stop Christmas—1991 Christmas Print

SENSE OF SERENITY I FIND VERY CONDUCIVE TO CREATIVITY. AH! THE WILD AND WOOLLY WEST!

ONE OF THE JOYS OF MY LIFE IS BEING ABLE TO PAINT IN MY OWN STUDIO IN MY OWN HOME. I PAINT EVERY DAY STARTING AROUND NINE AND LAYING MY BRUSHES DOWN WHEN MY BRAIN TURNS TO OATMEAL. I LOVE TO LISTEN TO BOOKS READ ON TAPE WHILE I'M

PAINTING TO GET THE BEST OF BOTH WORLDS, LITERARY AND ARTISTIC— AND TO GET IDEAS FOR PAINTINGS. YOU SEE, IDEAS COME FROM MANY SOURCES—MOVIES, POETRY, MUSIC, ETC., OR JUST LOOKING OUT THE WINDOW. QUITE FREQUENTLY, WE ARE TREATED TO A PERFORMANCE BY OUR CATS—ZORRO, MONTANA DE ORO, MAX, MABEL, AND REMINGTON.

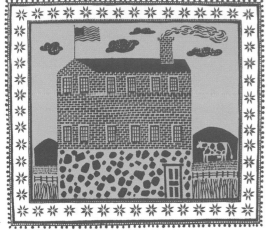

Home Sweet Home

CHEERS FOR THE GINGERBREAD BOYS!
LITTLE MOUTHS SMACKING WITH JOYS
MAMA BAKES THEM BROWN AND HOT!
GINGERBREAD BOYS EAT A LOT.

BACH's MAGNIFICAT in D MINOR

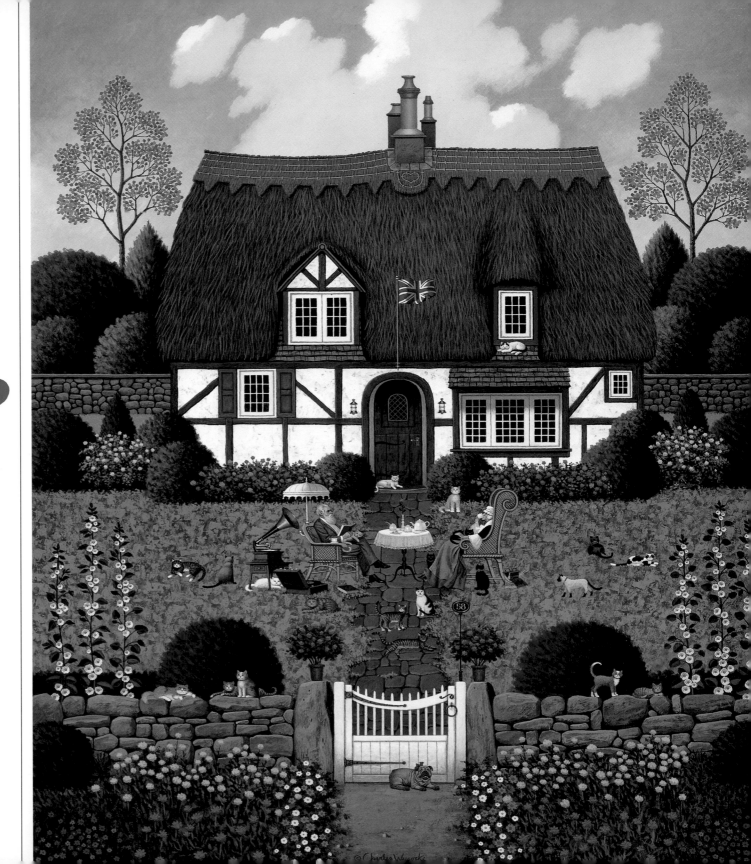

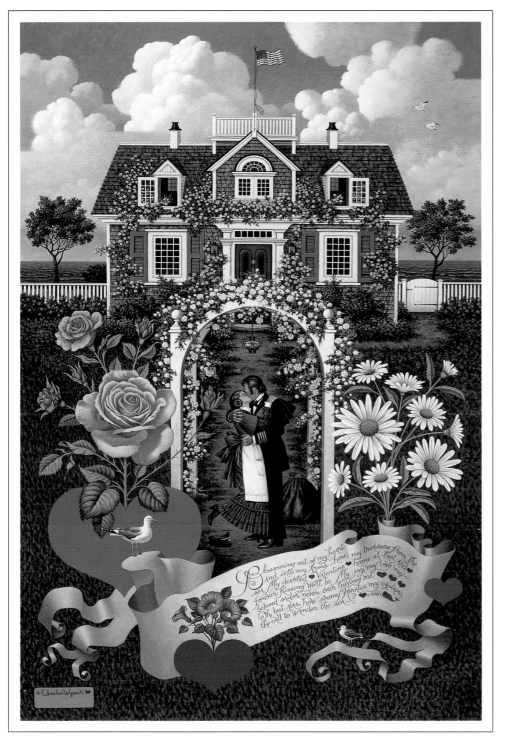

Home is My Sailor

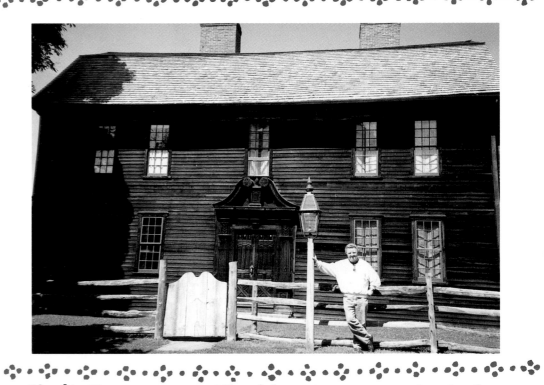

Chuck's Favorite House: The Ashley House, Deerfield, Mass.

We Eat and we Laugh
We have a good Time
The cold air Made warm
By Love deep and Sublime

So we sing and WE bake
AND eat our Sweet CAKE
With Whistle and Smile
Happy times we do While

Hearts And Flags

MY LIFELONG PATRIOTISM GOES BACK TO MY CHILDHOOD WHEN WE CELEBRATED THE FOURTH OF JULY WITH PARADES AND MARCHING BANDS. THE STREET WAS A TUNNEL OF RED, WHITE, AND BLUE. EVERY HOUSE HUNG OUT A FLAG. LITTLE KIDS WAVED LITTLE FLAGS. I PUT AMERICAN FLAGS IN MY PAINTINGS BECAUSE JUST THE SIGHT OF THE STARS

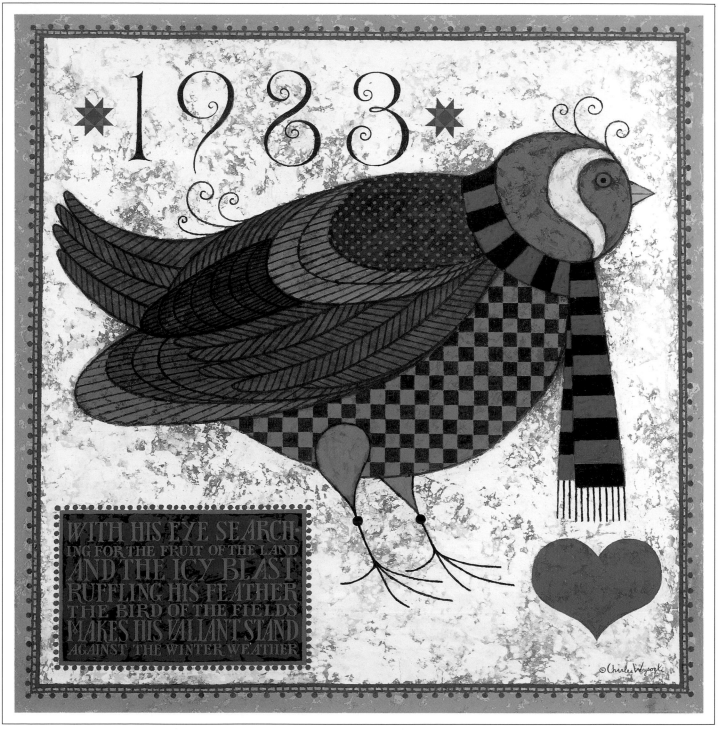

COMMEMORATIVE PRINT 1983—THE BIRD OF THE FIELDS

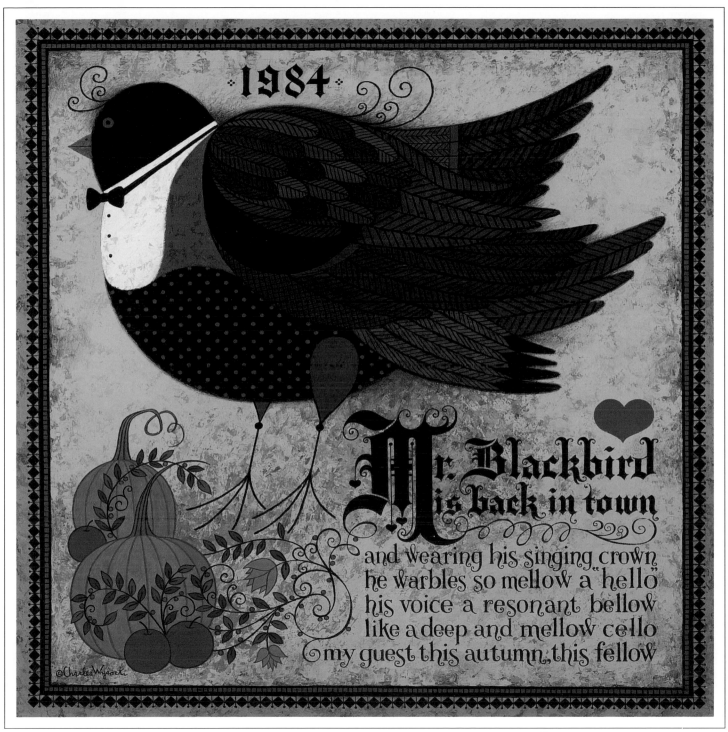

COMMEMORATIVE PRINT 1984—MR. BLACKBIRD

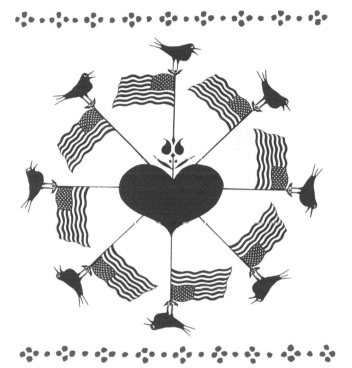

AND STRIPES GIVES MY HEART A LIFT. WHEN YOU ARE IN YOUR FORMATIVE YEARS, MANY THINGS REMAIN IN YOUR HEAD FOREVER. OLD GLORY, WHEN I WAS A YOUTH, WAS FIRMLY PLANTED IN MY PSYCHE. I WAS WONDERFULLY

BRAINWASHED IN RED, WHITE, AND BLUE.

I HAVE A COLLECTION OF ANTIQUE FLAGS, MANY OF THEM GIVEN TO ME BY PEOPLE WHO KNOW MY PAINTINGS AND KNOW THAT I WILL TREASURE THE FLAGS THEY GIVE TO ME. I DIS-PLAY THESE FLAGS IN MY STUDIO, AND I HAVE JUST PUT UP A

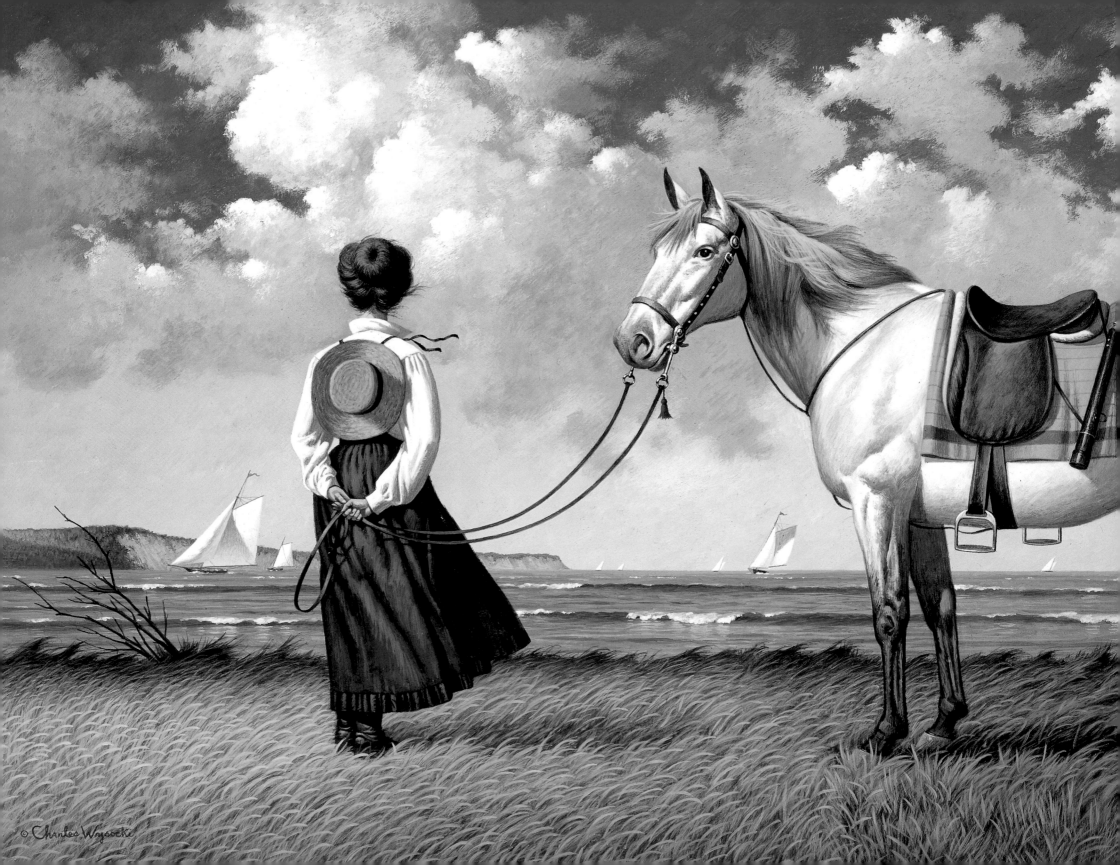

FLAGPOLE OUTSIDE OUR DESERT HOME SO THAT I CAN FLY SOME OF THESE WONDERFUL OLD FLAGS IN THE GREAT OUTDOORS. IT'S DIFFICULT SHIMMYING UP A

FLAGPOLE WHEN THE CORD BREAKS AND NEEDS TO BE RETIED—WHEN YOU'RE 64 IT'S A MOUNTAIN AND MAY REQUIRE HOSPITALIZATION.

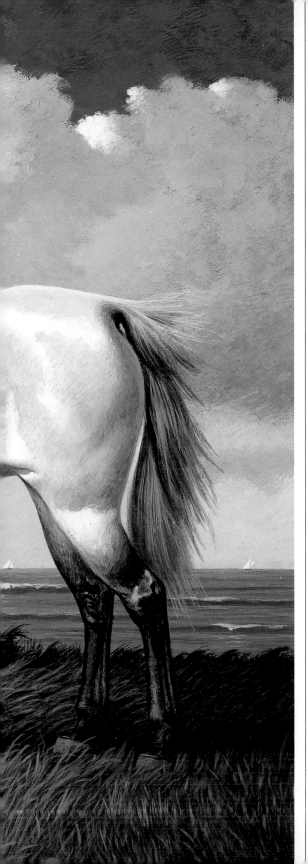

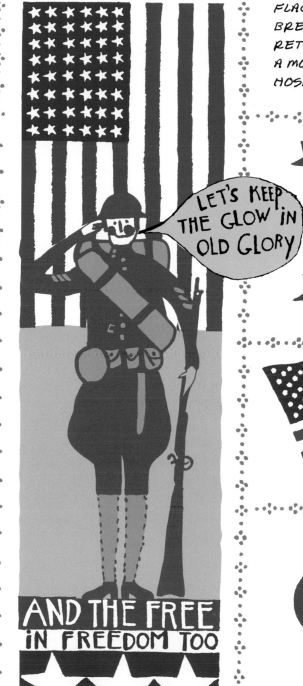

Sea Captain's Wife, Abiding

The Art of Life

FOR ME, PAINTING IS SO MUCH FUN, I CAN'T BELIEVE IT'S LEGAL. I CAN HARDLY WAIT TO FINISH BREAKFAST AND DASH INTO MY STUDIO TO GET SWALLOWED UP IN MY OWN LITTLE WORLD. THE MOST FUN IS ADDING A TOUCH OF LEVITY TO THE WORK. THAT CAN BE DONE WITH THE ACTION OF

A glass is good
 and A Lass is good,
and a Pipe TO SmokE
 in coLd weathER;
the World is good, And
 People are good,
and we're ALL Good fellows
 TogEther.

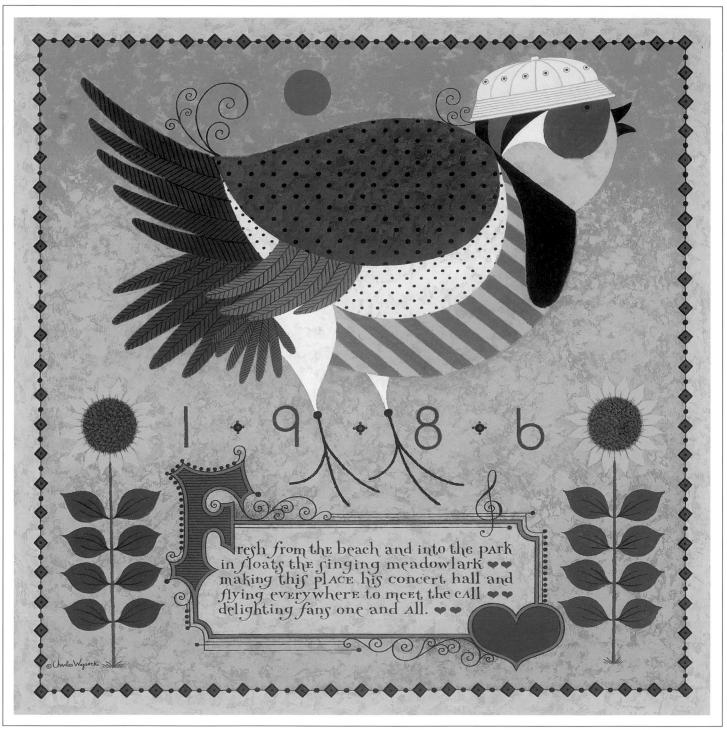

COMMEMORATIVE PRINT 1986—MR. MeadowLark

1 · 9 · 8 · 6

Fresh from the beach and into the park
in floats the singing meadowlark ♥♥
making this place his concert hall and
flying everywhere to meet the call ♥♥
delighting fans one and All. ♥♥

© Charles Wysocki

NOSTALGIA AND PATRIOTISM GUIDE THE BRUSH WHEN CHARLES WYSOCKI PAINTS HIS PORTRAITS OF AMERICA

The only thing unflagging about Wysocki (at his guest house) is his love for the Stars and Stripes; at right, Nantucket Fourth of July.

The rain pelted down on a long line of people outside a gift shop in Stow, Ohio. For one woman it was a two-and-a-half-hour vigil before she reached the man they'd all come to see. The welcome was for Charles Wysocki, 57, and he was surprised at the turnout. "You people must be crazy!" Wysocki said. "I wouldn't wait this long to see me." That becoming modestly somehow fits the man who is probably the

nation's foremost living painter of Americana and rates one at walls hall at Norman Rockwell. After Wysocki signed the waterlogged woman's $165 print, she declared, "We wouldn't have waited this long to see the President!"

Funny she should say that. Wysocki's homespun paintings are just what Ronald Reagan likes (though it is not known whether the President would stand in line to buy one). But

when he was Governor of California, Reagan did hang *Wysocki's Birch land River Farm*, a maple-sugaring scene, in his office. Reagan even wrote the artist saying how much the painting cheered him each morning.

The *Today* show commands his work too. Wysocki was recently profiled on the telecast. His celebrity, in fact, is widespread even without the help of Reagan and TV. Autograph seekers

Photographs by Jim McHugh/Visages

CONTINUES

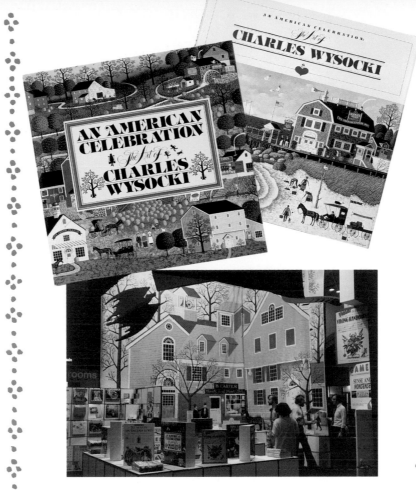

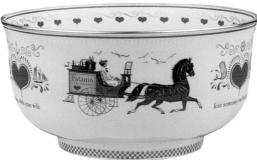

Some Highlights

Dust jackets from Wysocki's *An American Celebration* and its limited edition (right); bookstore promoting *An American Celebration* with Wysocki-style backdrop; Wysocki's *Americana Bowl* executed in a limited edition for The Greenwich Workshop by Pickard China.

It's a New Hampshire tradition— to choose our next President.

For as long as there has been a primary in New Hampshire, no one has ever been elected President without winning there.

Tonight, Peter Jennings and David Brinkley and the ABC News team will be on the scene, as the hopes and careers of the candidates are shaped and changed by the traditions of old New England.

What happens in November begins in February. Let ABC News take you all the way.

The &84 Vote

ABC NEWS SPECIAL TONIGHT 11:30 PM **7**

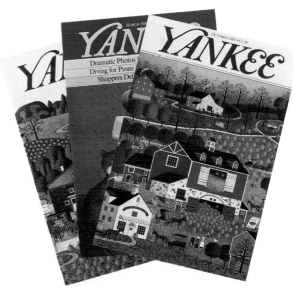

Advertisement for ABC News; cover illustrations from Yankee Magazine, Yankee Publishing, Inc.

A FIGURE, COSTUMING, TREES, ROCKS, BUILDINGS, SIGNS, ANIMAL ANIMATION. CATS AND DOGS ARE ALWAYS GOOD FOR A LAUGH. FOR ME, THERE IS NO CONFLICT BETWEEN WORK AND PLAY.

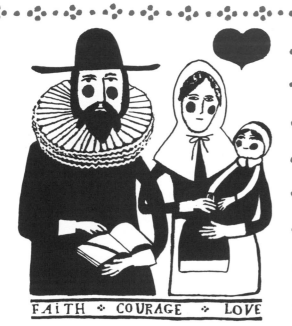

FAITH ✦ COURAGE ✦ LOVE

TRAVEL, READING, LOOKING AT TELEVISION, GOING TO THE MOVIES— THESE ARE SOME INSPIRATIONS FOR PAINTING.

THE REAL FUN IS IN FINDING NEW CHALLENGES AND MEETING THEM. WHENEVER I FEEL I HAVE FOUND A PAINTING FORMULA, I DECLARE AN IMMEDIATE BURIAL. BRUTAL, YES, BUT CHANGE IS NECESSARY TO MAINTAIN THAT EXCITEMENT WHICH LEADS TO ARTISTIC FULFILLMENT.

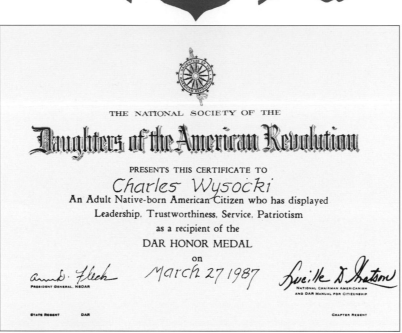

THE NATIONAL SOCIETY OF THE

Daughters of the American Revolution

PRESENTS THIS CERTIFICATE TO

Charles Wysocki

An Adult Native-born American Citizen who has displayed
Leadership, Trustworthiness, Service, Patriotism
as a recipient of the

DAR HONOR MEDAL

on

March 27 1987

PRESIDENT GENERAL, NSDAR

NATIONAL CHAIRMAN AMERICANISM
AND DAR MANUAL FOR CITIZENSHIP

STATE REGENT DAR CHAPTER REGENT

MEDAL OF HONOR

The Medal of Honor is awarded to an adult native-born citizen who has given outstanding service which has contributed to the betterment of the community.

CHARLES WYSOCKI, artist, creator of the Americana Calendar since the early 1970's, demonstrates his love of America with every stroke of his brush. He exemplifies our heritage and the values which have made our country strong. Love of family, community involvement, the old fashioned work ethic and patriotism are always subjects in his paintings. The American flag always flies high. Children in particular learn about our heritage, and they learn to honor our flag.

ALTHOUGH THE STYLE AND SUBJECT MATTER MAY BE SIMILAR, EVERY PAINTING I HAVE DONE HAS BEEN IN SOME WAY DIFFERENT. AND THERE HAS BEEN A SUBTLE PROGRESSION. THROUGH THE YEARS, I HAVE BECOME MORE AND MORE INTERESTED IN THE PEOPLE IN MY PAINTINGS. I THINK ABOUT WHAT THEY ARE DOING, WHERE THEY ARE GOING, AND WHY.

IN THE PAST, I'VE USUALLY DEPICTED PEOPLE IN GROUPS, FROM A DISTANCE. NOW I'M EAGER TO MOVE IN AND CREATE CLOSE-UPS

EARLY AMERICAN PAINTINGS by Charles Wysocki

OF ONE OR TWO CHARACTERS OR MORE IN A REVEALING OR INTRIGUING SITUATION.

BUT WHILE I MAY VIEW IT FROM VARIOUS ANGLES, THE EMOTIONAL LANDSCAPE OF HEARTLAND WILL NEVER CHANGE. IT REMAINS A WORLD AS WE WANT IT TO BE: LOVING, HAPPY, AND FREE. WHATEVER I PAINT, THERE MUST BE SOMETHING THERE THAT WARMS THE HEART.

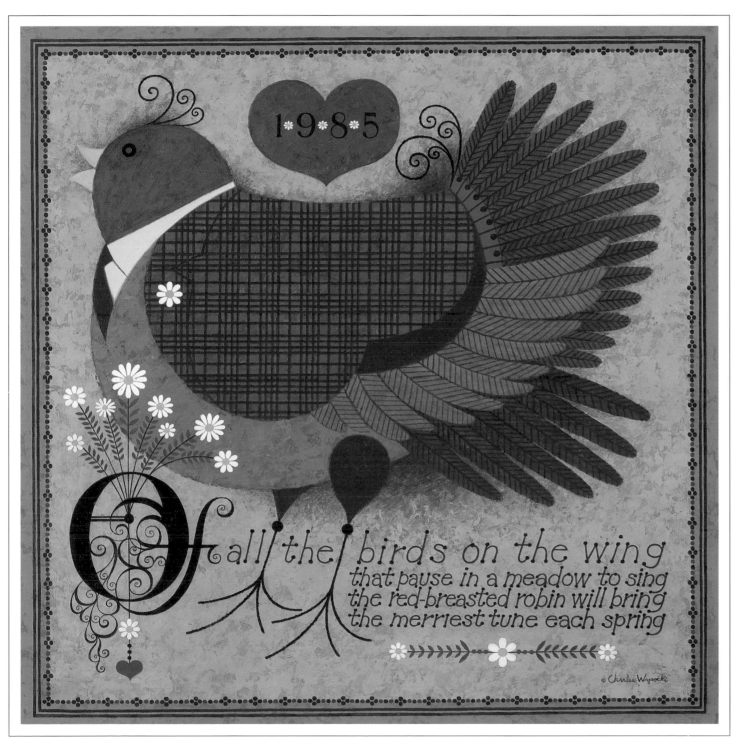

COMMEMORATIVE PRINT 1985—Mr. SPRING

- Keep Mind open To new ways of Thinking.
- Closer Observation of ALL Life around Me.
- ALign Myself with aLL ART that Touches THe heart.
- Study and Learn from the OLd Masters.
- AcryLics OR Water-Based Oils— cLEan, durabLe, fLexibLe. Paintings Should be Easy To Maintain.
- Patience and SweaT.
- Aim for Ideas with emotionaL iMpact That warm My SouL and Make My heart beat A LittLe faster—But noT So fasT That I wiLL be deLivered To the DeviL.

Tonight we Dined by CandleLight
This Heavy meal was a great delight
We Relished Each and Every bite
Now Our Tummies are Round and fat
We Love our Snug Little habitat
Has anyone Seen The Master's Cat?

Shall We?

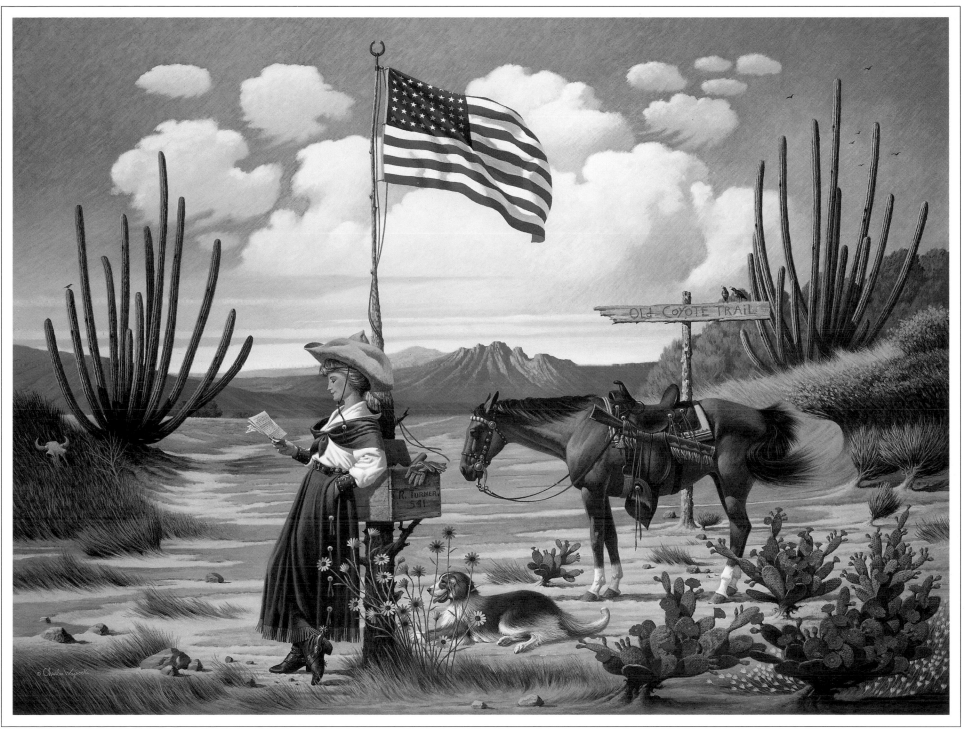

LOVE LETTER FROM LARAMIE

Inspirational Artists

❤Think about characterization, people, action, and emotion.
❤N.C. Wyeth
❤Howard Pyle
❤Eastman Johnson
❤John Singer Sargent
❤Thomas Eakins
❤Tom Lovell
❤Winslow Homer: "Breezing Up", "Fog Warning", "Girl with Laurel," "Eight Bells"

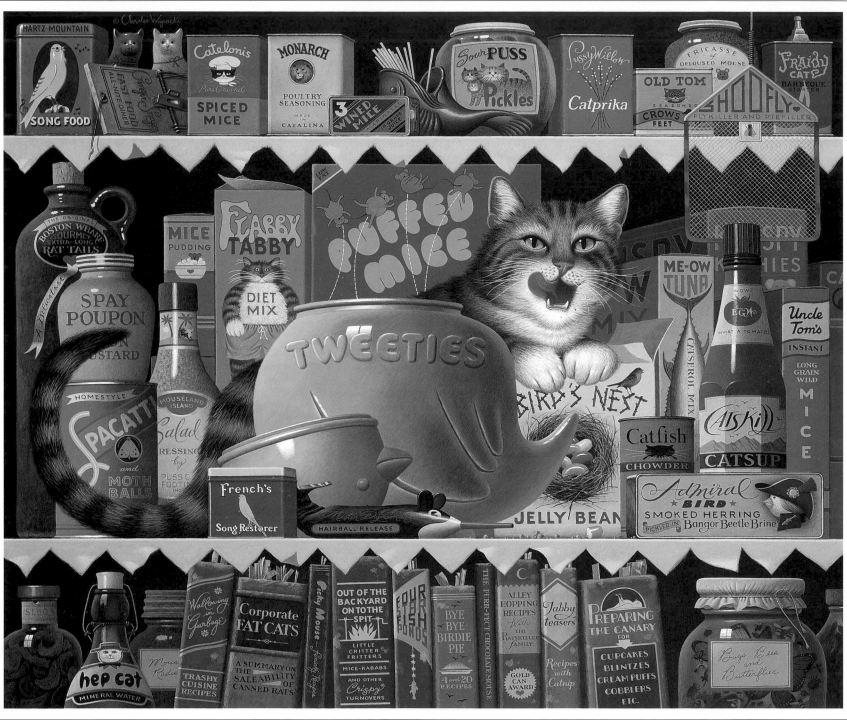

Ethel The Gourmet

138

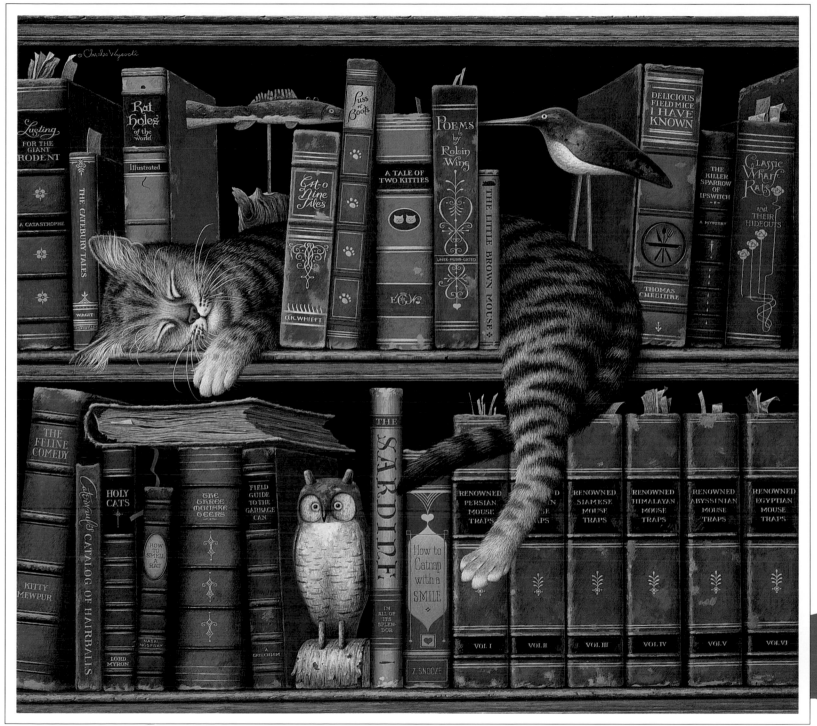

Frederick The Literate

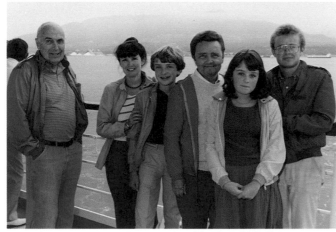

On The way To Alaska, From Left;
Liz's Father, Bill Lawrence; Liz, Matt,
Chuck, Millie and David.

Paintings I Want To Create

♥ An Outdoor Winter Vermont Christmas Scene.

♥ A WinterTime Boston night Scene.★

♥ A Victorian Boathouse and woody Motorboats.

♥ A Cape Cod Clambake.

♥ Olde Bucks County Commercial Country Center.

♥ Puzzle Makers indoors.

♥ Something To do With Chimney Sweeps.

♥ A Painting containing Blackbirds, Ravens, and Crow.

♥ A Victorian ice-boating Scene.

★ Bostonians And Beans

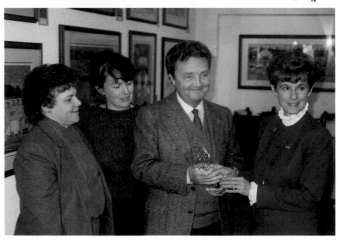

Chuck Receiving the Key (Hospitality Goblet) To the City of Toledo, Ohio, From the Mayor.

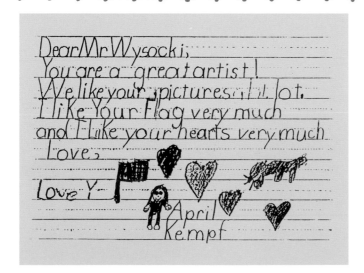

Dear Mr Wysocki;
You are a great artist!
We like your pictures a lit lot.
I like Your Flag very much
and I like your hearts very much
Love,
Love Y.
April Kempf

My Name is Chris
Dear. Mr. Wysocki;
You are a great artist!
We like your pictures a lot.
The part I like best is your cats
In the basket by the flowers.
Love, Chris A.

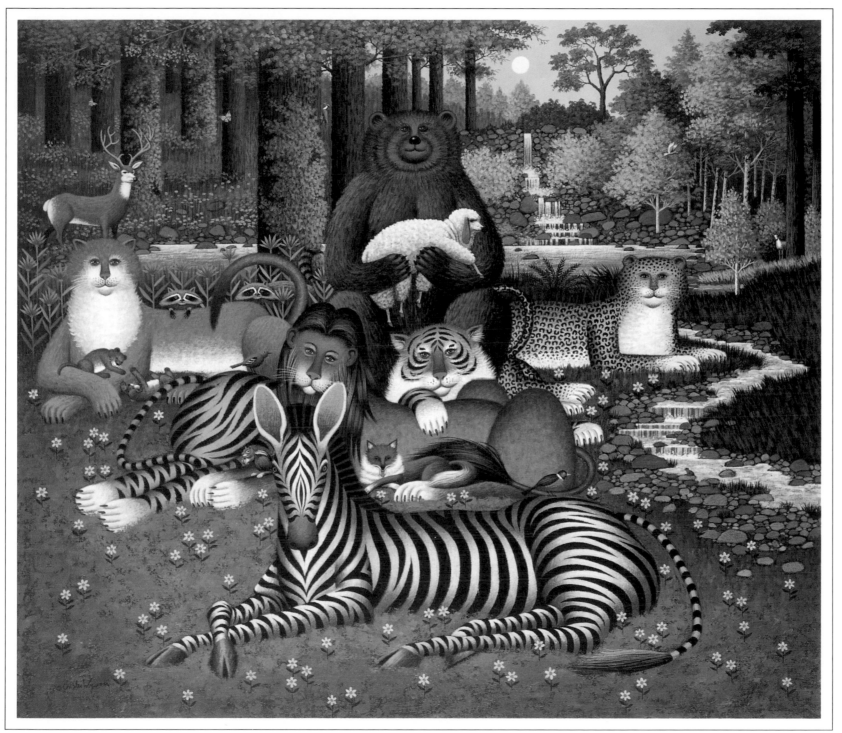

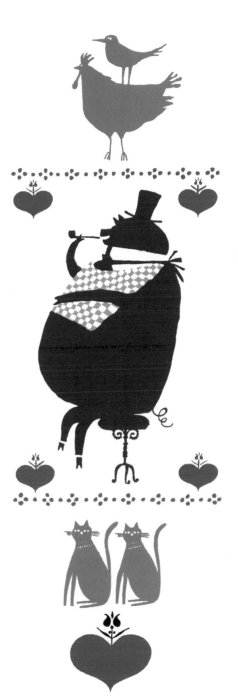

Chumbuddies

86

I Love America

SPIRIT OF THE SEA

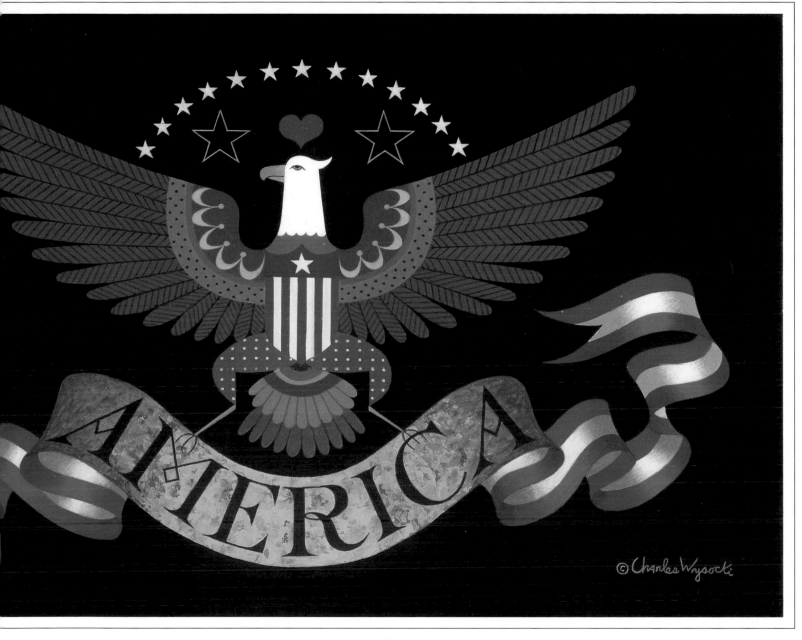

AMERICA

© Charles Wysocki

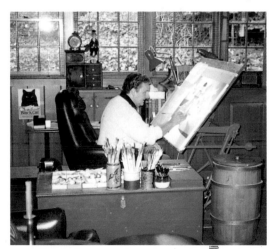

LIST of PAINTINGS